THE AMERICAN ASSOCIATION MILWAUKEE BREWERS

"Pongo Joe" Cantillon.

THE AMERICAN ASSOCIATION MILWAUKEE BREWERS

Rex Hamann and Bob Koehler

Copyright © 2004 by Rex Hamann and Bob Koehler
ISBN 978-0-7385-3275-2

Published by Arcadia Publishing
Charleston SC, Chicago IL, Portsmouth NH, San Francisco CA

Printed in the United States of America

Library of Congress Catalog Card Number: 2004103582

For all general information contact Arcadia Publishing at:
Telephone 843-853-2070
Fax 843-853-0044
E-mail sales@arcadiapublishing.com
For customer service and orders:
Toll-Free 1-888-313-2665

Visit us on the Internet at www.arcadiapublishing.com

Contents

Acknowledgments		6
Introduction		7
1.	The Advent of a New League in the Cream City: 1902–1911	9
2.	Rounding O ut the Deadball Era: 1912–1921	23
3.	From Gearin and Griffin to Gerken and Gullic: 1922–1931	37
4.	The Rise and Fall Decade: 1932–1941	79
5.	Wither the Foam Atop the Brew: 1942–1952	93
Appendix: The Milwaukee Brewers in Post-Season Play		127
Bibliography		128

Acknowledgments

The authors wish to acknowledge the following people for their contributions of assistance to this project.

Bob Evans, Brian Podoll, Marc Okkonen and Harold Esch assisted in research by contributing their knowledge, materials, and time.

Jason Christopherson lent his knowledge and expertise for this project.

George Estock provided photos of himself and provided material for research, as well as the generosity of his own time during interviews. George inspired the continued forward movement of this project.

Ted Gibson offered photos and information regarding his grandfather, Claude Elliott.

Judith Gloyer, Marion Kusnick, Sue Mobley and Virginia Schwartz of the Milwaukee Public Library acted as liaisons in our effort to locate historical photos of the Milwaukee Brewers and Athletic Park. Paula Kiely finalized the library's approval for our use of the images from their historical photograph collection.

Susan Otto of the Milwaukee Public Museum led us to important historical photos of Athletic Park and gave us permission to use the museum's items.

Lance Richbourg, Jr. shared photos of his father, Lance Richbourg, as well as other photos from his collection.

Neal Rink provided photos and inspiration regarding Joe Hauser, while Bill Schrank reflected on Hal Peck.

Jeanne Squires provided photos of her father, former Brewer star Tedd Gullic, and helped with questions regarding research. Her complete unselfishness, unmitigated enthusiasm and friendship assisted us in our quest.

Mrs. Joe Stephenson provided photos of her husband, former Brewer catcher Joe Stephenson, and Mrs. George "Slick" Coffman supplied valuable information.

Bert Thiel and Bill Topitzes provided photographic images and inspiration for this project.

In addition, Pat Woolley provided photos of her father, Forest "Tot" Pressnell, and helped with questions regarding research.

And a hearty Thank You goes out to the many former members of the Milwaukee Brewers and their family who took the time to respond to our questionnaires, including: Floyd Baker, George "Bingo" Binks, Mrs. Charles Brewster, Cy Buker, Jim Delsing, Jack Dittmer, George Estock, Ernie Johnson, Richard Manville, Gene Mauch, Al Milnar, Luis Olmo, Johnny Schmitz, Bert Thiel, and Earl Wooten.

Unfortunately, there wasn't sufficient space in this short volume to include all the wonderful accounts and stories that each of these remarkable players contributed to the history of baseball at Borchert Field, but their effort is hereby recognized nonetheless.

The authors also wish to thank the numerous cemetery employees over the past few years who aided in the search for the graves of many former players who donned a Milwaukee Brewers uniform at one time or another.

And finally, a grateful thank you goes to my wife, Keitha, who assisted with this project in a variety of ways.

INTRODUCTION

You've seen the signs: "If you weren't born before this date in, (say 1948 . . .)we can't sell you (cigarettes, beer, etc.)!" Well the same may hold true if you grew up in Milwaukee: If you weren't born prior to 1952, we're sorry but you missed out on one of the most phenomenal minor league baseball teams in the history of sport, those wonderful Milwaukee Brewers in old "Borchert Orchert." The Brewer became the second-winningest franchise in the American Association in their 51 seasons on Milwaukee's near north side.

Perhaps you were among the fortunate few who had the opportunity to stretch out in the sun-soaked stands at Borchert Field to witness minor league baseball at its best. During the first-half of the twentieth century, baseball was a form of entertainment that attracted thousands of enthusiastic fans into parks around the country. People didn't see their heroes as the overpaid transients that we're accustomed to today, but the modern fan isn't generally aware of how the diamond performers of yesteryear were little more than indentured servants to a team's owner. There's always a downside.

Fans came to readily identify with the ballplayers back in those earlier, more "innocent" times. Players were often underpaid and their travel circuits arduous. When the off-season came, those who earned respect upon a ball field and may even have experienced a modicum of glory became laborers toiling within the noisy and dangerous confines of America's factories, or perhaps they endured upon hard scrabble farms to help their families eke out an existence.

Factories and jobs abounded in Milwaukee as the city continued to grow during the first half of the twentieth century, and it just may have been the perfect place to grow up if the community could support a professional baseball team. For a duration of 51 seasons (1902–1952), the Milwaukee Brewers occupied the same quirky little wooden ballpark at 8th and Chambers Streets on the city's near north side, providing entertainment and generating numerous heroes for countless Milwaukee residents.

The Brewers provided continuous high-level baseball for over 1.8 million fans during its 51-year tenure in the league. Old Borchert Field, built in 1888 as Athletic Park, became a rickety little oddity during its 60 plus years of existence. But it offered a haven for baseball fans who wanted nothing more than to leave their cares and troubles behind and soak up the sunshine as their local heroes contested rival regional teams on real grass beneath a wide open sky.

Independently owned during the first-half of their tenure in the American Association, Brewer owners made money, no doubt, but they were constantly running the club on a shoestring; according to one knowledgeable observer of the local scene, the Brewer team, despite facing bankruptcy on more than one occasion, never had more than three successive losing seasons. Compare that record to the current National League Milwaukee Brewers whose fans remain loyal despite a lengthy span of losing seasons.

If you were raised on the old Brewers, you may recall many of the names and faces included in this book. Many are obscure, a few became famous, and one or two may have made it to the Baseball's grand pinnacle of achievement, The Hall of Fame. Regardless, this thin volume stands as a tribute to all the former players, managers, and coaches who ever wore the woolens

for Milwaukee. If you've never heard of Tom "Sugar Boy" Dougherty, Stoney McGlynn, Ivy Griffin, Dinty "Kewpie" Gearin, Bunny "Bunions" Brief, Tedd Gullic, Al Sothoron or Nick "Tomato Face" Cullop—names which were at one time household words throughout the city—perhaps by investing a small portion of your time within these pages, you'll become acquainted with these men and others who were heroes to kids in the Milwaukee of yesteryear, and maybe to some of the grown-ups as well.

During the first half of the 20th-century, the Milwaukee Brewers represented the people of the Cream City (so called due to the cream color of the locally produced brick which came from the nearby quarries), and stood as a microcosm to the city's population: hard-nosed, hard-working and hard-playing. The result was a solidly successful ball club, which, through good times and bad, had the resourcefulness and pluck to maintain their passion, their love of the sport, and their desire to win, despite the odds. It is the intent of this book to provide a sense of the strength of that baseball spirit of the intensely competitive yet fun-loving players of yesterday.

From the Brewers' mascot goat "Woozey" (one can only speculate on how this name came about) to "Owgust," the barrel-chested ballplayer figure which became the popular graphic representative of the Brewers' ball club, the colorful history of this team has been represented by various figures through time. It is a privilege for us to introduce many of these colorful characters to you here.

Within these pages you will be treated to numerous rare photographs, most of which have never been seen by the general public and until now have been in the hands of private collectors. It is through the generosity of these individuals and institutions that this little book is possible.

(Note: In parentheses after each player's name the player's years of service with Milwaukee are listed.)

GEORGE STONE, BATTING CHAMPION FOR 1904 (1904; 1911). Stone came to the Brewers as a 26-year old outfielder from Lost Nation, Iowa after a brief appearance with the Boston Pilgrims in 1903. He set the American Association afire with his .405 batting average in 626 at-bats, which also led the league and stands as the all-time league record. His 254 hits was a league high as well, and he led the Brewers in doubles with 36. Stone went on to a successful career with the St. Louis Browns. (Photo courtesy of the Milwaukee Public Library.)

ONE
The Advent of a New League in the Cream City
1902–1911

In 1901, Thomas J. Hickey wrote to the postmasters of eight Midwestern cities to request their opinion on the prospect of professional baseball in each city. Their favorable replies became the seed that blossomed into the American Association, a new baseball league evolving primarily from teams of the former Western League.

The American Association was originally an independent entity, and the other league owners considered it as a "renegade" league. Under the direction of Hickey, the new league made its appearance in 1902, a band of brothers essentially comprised of former major leaguer players who weren't interested in being held by the reigns of the de facto major league teams of the time. Although a minor league, it was "minor" only in the sense that the prevailing interests of professional baseball, the National and American League owners, did not view the American Association or its players and teams to be equal in talent or value to their respective leagues. However, the popularity with which the fledgling "unofficial" organization was accepted across the Midwest indicates its early success in this baseball-hungry land during a time when "Base Ball" was not merely the national pastime, but the national passion.

The Milwaukee Brewers occupied sixth-place in the eight-team league by the time the curtain closed on the 1902 season. The Indianapolis Indians finished first, followed closely by the Louisville Colonels in second, the St. Paul Apostles (later known as the "Saints") in third, the Kansas City Blues in fourth, the Columbus Senators (renamed the "Red Birds" in 1930) in fifth, and the Milwaukee Brewers, Minneapolis Millers and Toledo Mud Hens bringing up the rear in that order. The Toledo ball club moved to Cleveland and became the Spiders from 1914 to 1915; they returned to Toledo as the "Iron Men" in 1916 before finally regaining their former nickname of "Mud Hens" in 1919. Reflecting the wisdom of those original eight postmasters, the eight original entries of the American Association remained steadfast as the only members of the league for over one-half of a century.

While the Brewers did not capture the American Association crown through the first decade of their existence, they came close in 1909. The prime victor wasn't in place until the final week of that season, as Louisville squeaked past both the Millers and the Beer Boys. But with an overall record of 795 wins and 745 losses during their first decade, the Brewers proved they were a force to be reckoned with, a reputation that would stay with them throughout their tenure in the league. This was the team that put Milwaukee baseball on the map.

Under managers Bill Clingman (1902), Joe Cantillon (1903–1906), Jack Doyle (1907), Barry McCormick (1908), John J. McCloskey (1909–1910), and Jimmy Barrett (1911), the Suds Busters compiled a .516 winning percentage, with a won-loss record of 795-745. "Pongo Joe" Cantillon was the most successful among the earliest Brewmasters, as he led his company of deadballers to a record of 342-249, for a remarkable winning percentage of .579. Cantillon would go on to captain the Minneapolis Millers during one of the team's most successful stretches.

Brewer highlights for the decade include Claude Elliott's 226 strikeouts in 1903, George Stone's .405 batting average (626 at bats) in 1904 and Stoney McGlynn's 446 innings pitched with 27 wins and 14 shutouts in 1909, all long-standing league records.

CLAUDE JUDSON ELLIOTT (1902–1903). Pictured here as a member of the 1905 World's Champion New York Giants, Elliott was the Opening Day pitcher for the Brewers in their inaugural game in the American Association on April 23, 1902 at East Washington Street Park in Indianapolis. All tolled, the Wisconsin native known as "Old Pardee" or "Chaucer," achieved a record of 35-31 in his two season with Milwaukee. In 1903, he topped the league in strikeouts with 226, a record which still stands as one of the top ten in that category in Association history. (Courtesy of Ted Gibson, grandson of Claude Elliott.)

THE 1904 MILWAUKEE BREWERS. Under the leadership of another Wisconsin-born ballplayer, Joe "Pongo Joe" Cantillon, the Brewers finished in third place with a record of 89-63 in 1904. From left to right: Team Captain Germany Schaefer (ss), Cliff Curtis (p), Jack Slattery (c), Quate Bateman (p/1b), Lou Manske (p), Tom "Sugar Boy" Dougherty (p/of), Elmer "Spitball" Stricklett (p), Art Pennell (of), Kid Speer (c), Jack O'Brien (2b/of), Reeve McKay (p), Frank Hemphill (of/2b), George Stone (of), and Harry "Pep" Clark (3b). Team mascot "Little Hans" is seated. (Photo courtesy of the Milwaukee Public Library.)

THREE MILWAUKEE ACES FOR 1905. From left to right, Harry "Pud" McChesney (of/3b), Frank Hemphill (of), and Jack Slattery (c) appear in this photo. McChesney led the team in doubles (27, tied with catcher Monte Beville) and in stolen bases (32, tied with shortstop Clyde "Rabbit" Robinson). (Courtesy of the Milwaukee Public Library.)

THE 1905 MILWAUKEE BREWERS. The Milwaukees climbed to second place in the standings with a record of 91-59, their best finish yet in the young American Association. Tom Dougherty, a native of Chicago, led the mound corps with his 22 wins against 17 losses, striking out 156 batters in 340 innings of work—a league high. From left to right: (front row) Joe Cantillon (mgr.), Clyde Robinson (ss), Harry Clark (3b), Harry McChesney (of/3b), and Jack Slattery (c); (middle row) Monte Beville (c), Tom Dougherty (p), Jack O'Brien (1b/of), Barry McCormick (2b), and Frank Hemphill (of); (back row) Babe Towne (c), Clyde Goodwin (p), Quate Bateman (p/1b/of), and Cliff Curtis (p). (Courtesy of the Milwaukee Public Library.)

GRANDSTAND UNDER CONSTRUCTION AT ATHLETIC PARK. Located on the near north side of Milwaukee, Athletic Park was the home of the Brewers throughout their tenure in the American Association. It was built in 1888 and officially renamed Borchert Field many years later, around 1928. The construction of a new section of grandstand in the outfield, which occurred in 1910, was an improvement. (Courtesy of the Milwaukee Public Library.)

THE MILWAUKEE BREWERS OF 1909. The Brewers gave Louisville a run for their money but finished in second place with a record of 90-77, two and one-half games out. Righty Frank Schneiberg (back row, third from right) was a native Milwaukeean. Clyde Robinson holds the canine mascot, which appears to be the most excited about being photographed. From left to right: (front row) Stoney McGlynn (p), Robinson (ss), and Charlie Moran (c); (middle row) Newt Randall (cf), Harry Clark (3b), John McCloskey (mgr.), Barry McCormick (2b), Lou Manske (p), Robert Wallace (p), and Art Hostetter (c); (back row) Edward Collins (lf), Jack "Shad" Barry (rf), Larry Pape (p), Cliff Curtis (p), Frank Schneiberg (p), Tom Dougherty (p), and Dan McGann (1b). (Courtesy of the Milwaukee Public Library.)

STONEY MCGLYNN (1909–12). This T-206 Piedmont card, one of 350 in the series, shows the star pitcher for the Brewers who nearly led the team to their first AA championship. McGlynn's 27 wins against 21 losses both led the league, as did his 64 games, 446 innings, 183 strikeouts, 304 hits allowed and 14 shutouts, the latter a record which would never be matched in the American Association. (From the collection of Rex Hamann.)

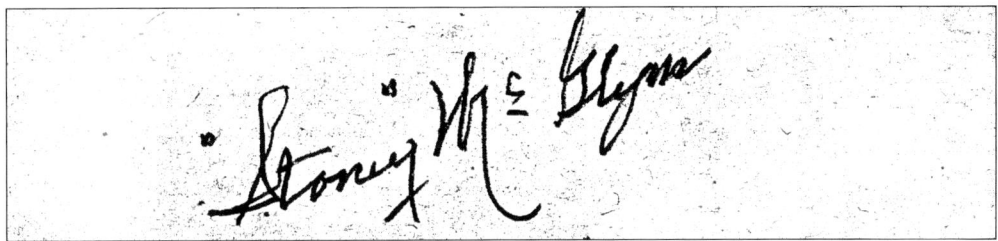

THE AUTOGRAPH OF STONEY MCGLYNN. His full name was Ulysses Simpson Grant "Stoney" McGlynn; appearing here is a photocopy of McGlynn's signature in its abbreviated form. A native of Lancaster, Pennsylvania, his mother was said to be a full-blooded Cherokee Indian. McGlynn once survived a poisoning attempt while a player in the Ohio-Pennsylvania League. (Courtesy of Harold Esch.)

THE GRAVE OF STONEY MCGLYNN. McGlynn's final resting place is located at Evergreen Cemetery in Manitowoc, Wisconsin, where McGlynn worked in the aluminum plants after his professional baseball career was through. His 1911 home address is shown as 776 N. 25th Street (old numbering system) in Milwaukee. Stoney died on August 26, 1941. (From the collection of Rex Hamann.)

JACK "SHAD" BARRY (1909–1910). This T-206 Piedmont card shows John C. "Shad" Barry. A regular in the Milwaukee lineup, the outfielder hit .236 in 1909, then raised his average to .252 for the 1910 season, which ranked third on the team. Batting averages during the "deadball" era were considerably lower than what occurred after the live ball was introduced around 1920. (From the collection of Rex Hamann.)

NEWT RANDALL (1908–1915). Randall starred as an outfielder for the team from 1908 to 1915. In 1909, he topped the American Association with 92 runs, appeared in 167 games and led the Brewers with a .279 batting average. Randall was born at New Lowell, Ontario, Canada in 1880 and died in 1955 at Duluth, Minnesota. (Courtesy of the Milwaukee Public Library.)

DAN MCGANN (1909–10). This T-206 Piedmont card commemorates the Brewers' first baseman who stole 22 bases and had a .245 batting average in 1909. McGann covered the first sack for the Milwaukees from 1909 to 1910. His real name was Dennis but he used his brother's name as a Brewer. On Tuesday, December 13, 1910, he was found dead in a Louisville hotel room, the victim of a gun shot from his own hand. (From the collection of Rex Hamann.)

JIMMY BARRETT (1909–1911). Pictured on this T-201 Piedmont Tobacco card is Milwaukee outfielder Jimmy Barrett who managed the team in 1911 while appearing in 72 games and hitting .224. Barrett played for the Brewers from 1909 to 1911, occasionally filling in at shortstop. In 51 games with Milwaukee in 1910, Barrett batted .353 with 173 at-bats. In major league annals, he is known for being one of four players who hit at least .300, score over 100 runs and steal at least 40 bases in his rookie year (1900), a distinction he holds with "Shoeless" Joe Jackson, Ichiro Suzuki, and current National League Brewers' outfielder, Scott Podsednik (2003). (From the collection of Rex Hamann.)

MILLING ABOUT BEFORE CONTEST WITH MILLERS, 1909. The Minneapolis Millers were in town as a crowd in Sunday attire gathers outside the ticket kiosks at Athletic Park, located at 8th and Chambers Streets in Milwaukee. Note the signal lamp hanging above the streetcar

lines traversing 8th Street. The sign on near kiosk says, "Bleachers 25 cents." (Courtesy of the Milwaukee Public Museum.)

THE AFTERMATH AT ATHLETIC PARK, 1909. A barrage of bottles and wooden beer cases represents the wrath of early Milwaukee patrons during a baseball game against the Minneapolis Millers as a few local observers survey the disaster in disbelief. The advertising on the outfield wall suggests Milwaukeeans were entering the electronic age. On one beer case the words "Val. Blatz" are

visible. Born in Germany, Valentin Blatz was a longtime local brewer who died in 1894 ,but his brewing legacy continued as the Val. Blatz Brewing Company whose products dominated the Milwaukee scene for over a century. (Courtesy of the Milwaukee Public Museum.)

WILLIAM "DOC" MARSHALL (1910–1913). The Brewers' backstop accumulated a .240 batting average in his years in the American Association. He was traded to St. Paul on June 20, 1912, then returned to Milwaukee for the 1913 season and batted .254 in 50 games with 126 at-bats. Marshall spent his major league career with several National League teams, beginning in 1904. (From the collection of Rex Hamann.)

CLYDE "RABBIT" ROBINSON (1905–1910) AND HARRY "PEP" CLARK (1904–1916; 1922–1925). These two hardscrabble infielders formed the nucleus of the Brewer infield for years during the deadball era. West Virginia native Robinson died prematurely at the age of 33 and is buried at Wellsburg, West Virginia, while the Ohioan Clark died in 1965 at the age of 85 in Milwaukee and is buried at Valhalla Cemetery on Milwaukee's west side. Clark owns the distinction of playing in more American Association games (1,834) than any other player—all as a member of the Milwaukee Brewers. He had a career .258 batting average. (Courtesy of the Milwaukee Public Library.)

AT MILWAUKEE.											
Milwaukee.	AB	H	O	A	E	Minneap's.	AB	H	O	A	E
Stone, lf.	5	1	4	0	0	Clymer, cf.	4	0	5	0	0
Charles, 2b	4	1	7	3	1	Altizer, ss.	5	4	1	2	2
Orendorff, 1b	4	1	9	1	0	Cravath, lf.	4	0	1	0	0
Dougherty, rf.	5	2	0	0	0	Williams, 2b.	4	2	2	2	0
Barrett, cf.	4	0	2	0	0	Rossm'n, rf	3	0	1	0	0
Clark, 3b	3	3	2	3	0	Gill, 1b.	3	2	11	1	0
Breen, ss.	3	0	1	3	1	Killifer, 3b.	3	2	1	4	0
Marshall, c.	4	1	5	6	0	Smith, c.	3	1	5	0	0
Marion, p.	2	0	0	1	0	Waddell, p.	2	0	0	1	0
Cutting, p.	1	0	0	1	0	Owen, c.	1	0	0	0	0
*Randall	1	0	0	0	0	Peters, p.	0	0	0	2	0
						*Leever	1	0	0	0	0
Totals	36	9	30	18	2	Totals	35	11	†27	12	2

BOX SCORE FROM MONDAY, JULY 17, 1911. The fifth-place Milwaukee Brewers defeat the 1911 future AA Champion Minneapolis Millers with a late rally despite being out-hit. Dave Altizer has four hits for Cantillon's Millers, while Milwaukee third baseman Harry "Pep" Clark goes three-for-three. The Millers were in second place behind Columbus at the time this game was played. (From the July 24, 1911 edition of *The Sporting News* in the collection of Rex Hamann.)

MILWAUKEE, WIS., TEAM—American Association
1, Nicholson; 2, Charles; 3, Lewis; 4, Short; 5, Dougherty; 6, Jones; 7, Marion; 8, Ralston; 9, Dolan; 10, Schalk; 11, Leibold; 12, Breen; 13, Barrett; 14, Cutting; 15, Clark; 16, Stone; 17, Randall; 18, McGlynn.

THE MILWAUKEE BREWERS OF 1911. The team completed its season in fifth place under player-manager Jimmy Barrett who led the team to a 79-87 record, twenty and one-half games behind front-running Minneapolis. Barrett began his professional baseball career with Cincinnati in 1899. The Brews' leading hitter (300 plus at-bats) was Phil Lewis who played in 161 games at shortstop and hit .301. Stoney McGlynn rose to the fore in his last full year with Milwaukee, ringing up a record of 22-15 in 287 innings of work. (From *The Reach Official American League Guide*, photo by the Baker Art Gallery, from the collection of Rex Hamann.)

ROBINSON AND CLARK SQUARE OFF. These guys knew how to pose. Sharing a lighter moment with teammates, Clyde Robinson (left) jousts with fellow infielder Harry Clark. That's Tom Dougherty (far left), probably daring the photographer to enter the fray; and there's Stoney McGlynn (third from left, background) appearing to be ready to defend his turf. (Courtesy of the Milwaukee Public Library.)

TOM DOUGHERTY HEADS FOR THIRD. In this photo, *circa* 1909, pitcher Dougherty rounds the bases, heading for third. "Sugar Boy," a moniker he earned due to his diabetic constitution, hit .198 in 1909 while doing double duty as an outfielder for the Milwaukees. (Photo courtesy of the Milwaukee Public Library.)

Two
Rounding Out the Deadball Era
1912–1921

The second decade of American Association baseball on Milwaukee's near north side was a real roller-coaster ride. The Brewer's primary owner, Charles Havenor died on April 3, 1912 at the age of 50, after a 10-year tenure as the top man in the organization. His passing resulted in the transfer of club ownership to his widow Agnes who became a pioneer as one of the earliest women to own a high-level professional ball team. One of her first moves was to hire future Hall of Famer Hugh Duffy to lead the club, but his managerial skills didn't produce the desired effect, as the Brew Crew landed in fifth place for the second straight year with a record of 78-85, 26 games out of first.

But good times were just around the corner for the Milwaukee faithful as Mrs. Havenor adjusted her strategy by employing longtime Brewer third-sacker Harry "Pep" Clark as the new field general. Maintaining his post on the field, Clark was a multifaceted contributor to the Brewer's first American Association pennant in 1913. His .286 batting average was good for third best on the team, while his mates brought the club to a record of 100-67. Pitcher Cy Slapnicka led the league with his 25 wins against only 14 losses (.614 wining percentage), appearing in 47 games while working 321 innings.

But the Cream City Crew wasn't satisfied with just one championship, as they repeated their pinnacle performance in 1914 under Pep Clark, nearly equaling their previous year's mark in victories with 98 while suffering 68 losses. This time, Joe Hovlik was the jewel in the crown of the Milwaukee pitching staff with his 24 wins against 14 losses in 47 games. In 323 innings of work, Hovlik struck out 216 batters while walking 134 and earning a flattering 2.54 ERA. Veteran Brewer outfield Newt Randall batted .321 while stealing 21 bases—both top team marks. The Brewers would wait 21 years before being bestowed with the AA crown again.

One of the few highlights during the Brewers' second decade was the 1916 acquisition of the world famous Native American athlete Jim Thorpe (descended from Sac and Fox tribes), albeit during the most pathetic season in Brewer history. True to the form which made him famous, Thorpe led the Association in stolen bases with 48, and his .274 batting average was good for second on the team. But Thorpe's performance wasn't enough as the Brew Boys plummeted to the cellar with an unflattering 54 wins against 110 losses. Harry Clark bowed out after 113 games, presumably to tend to his ailing wife back in Ohio, with shortstop Jack Martin resuming the reigns. But it was too late to salvage the season. The Brewers would not escape the shackles of the second division until 1924.

Joe Hauser, the Milwaukee native who could do it all on the diamond, came to the aid of the ailing Brew Boys in 1920 when he appeared in 155 games, hit .284 and belted out a team-leading 15 home runs while driving in 79 runs—another team high. Yet the team was unable to rise past the sixth spot in the standings. The outfielder returned to the Brewers in 1921 when he let his bat do the talking as he drove in 110 runs while hitting 20 homers, elevating his batting average to an impressive .316. "Unser Choe" (German for "our Joe") was the moniker the Milwaukee crowds bestowed upon him as a staid crowd favorite on his way up to the major leagues. But the Milwaukees could do no better than fifth place, despite Choe's contributions to the club.

THE AMERICAN ASSOCIATION CHAMPION MILWAUKEE BREWERS OF 1913. Here's Harry Clark and his Brewer bombers for 1913. The team is pictured after capturing their first AA Championship by four games in the standings over Jack Hayden's Louisville Colonels. Outfielder Larry Chappelle was the driving force in the Brewers' lineup until the Chicago White Sox picked him up mid-season. In 350 at-bats, Chappelle was hitting .349 when he was called up to the Sox, an average virtually unheard of during the deadball era. But by that time the Brewers were well on their way to a dramatically victorious season. Manager/third-baseman Clark and veteran Brewer outfielder Newt Randall hit .286 and .288, respectively, with catcher Johnny "Runt" Hughes leading the team in doubles with 22. First-year Brewer outfielder Larry Gilbert clubbed a team leading 10 home runs, the highest team total since Quate Bateman socked nine

dingers in 1904. Iowan Cy Slapnicka led the league in victories with a record of 25-14, while Ralph Cutting, a dairy farmer from New Hampshire, was the league's leading pitcher with a record of 21-9 for a winning percentage of .700. From left to right: (front row) Ralph Cutting (p), Larry Chappelle (of), and Joe Hovlik (holding Cutting's pet goat "Woozey") (p); (middle) Larry Gilbert (of), Buster Braun (p), Cy Slapnicka (p), Tom Jones (1b), Harry Clark (3b/mgr.), Tom Dougherty (p), Joe Berg (utility infielder), and William "Doc" Marshall (c); (back) Jimmy Block (c), Rube Nicholson (p), Newt Randall (of), Johnny Hughes (c), Phil Lewis (2b), and Doc Watson (p). Not included in this photo are Russell (Lena) Blackburne (ss), Milwaukee native Oscar "Happy" or "Hap" Felsch (of), Big Bill Powell (p), Orville Woodruff (of), and Irving "Young Cy" Young (p). (Courtesy of the Milwaukee Public Library.)

HARRY CLARK. Clark poses for the camera later in his career, demonstrating the form which enabled him to occupy the third sack for the Brewers. He was Milwaukee's longest-tenured player, and later their manager, throughout the early years of the organization. Born at Union City, Ohio, Clark was beset by personal issues during the team's worst year in 1916. (From the Collection of Bob Koehler.)

TRIO OF BREWER INFIELDERS. In this photo (*circa* 1914) appear second-sacker Joe Berg (1913–1915), manager/third baseman Harry Clark and shortstop William "Jap" Barbeau (1914–1915; 1917-18). Barbeau came to Milwaukee after a four-year career in the major leagues (1905–1906; 1909–1910) and is one of 41 players with ten or more seasons of active duty in the American Association (1,336 games, career .268 batting average). He is buried at Holy Cross Cemetery in Milwaukee. (Courtesy of the Milwaukee Public Library.)

SAM "SONNY" BOHNE (1917). Shown here (*circa* 1930) as a Minneapolis Miller, Bohne came to the Brewers at the age of 20 after 14 games with the St. Louis Cardinals. His real name was Samuel Arthur Cohen. In 1929, Bohne was a central figure in one of the most memorable brawls in American Association history occurring at Nicollet Park in a classic contest between the St. Paul Saints and Minneapolis Millers on July 4, 1929. (From the collection of Bob Koehler.)

BILL "WEE WILLIE" SHERDEL (1916–1917). Shown here in his St. Louis Cardinal attire, the 5'10" Sherdel may have deserved his moniker at 160 pounds. In his two years pitching for Milwaukee, Sherdel bagged 21 wins against 21 losses over 53 games, capturing the team's league lead in wins with 19 in 1917. The southpaw would go on to a long major league career with the St. Louis Cardinals from 1918 to 1930, and again in 1932. (From the collection of Bob Koehler)

J.J. Egan (1918; 1920–1921). World War I pre-empted John Joseph "Rip" Egan's first year as manager of the Brewers, as the season was officially terminated in July of 1918. At the age of 46, Egan led the team to a 38-35 record that year as the team finished in fifth place. Returning to pilot the Brew City boys in 1920, Egan's crew mustered 78 wins against 88 losses for a sixth-place finish, a whopping 38 games behind St. Paul's superior Saints. The next season, his club showed improvement. The Brewers garnered an 81-86 record, good for fifth-place, a comparatively small 16.5 games out of first. Egan was a pitcher in one game for the 1894 Washington Senators. (From the collection of Bob Koehler.)

Bob Trentman (1918–1921). In his first year in a Milwaukee uniform, the pitcher saw action in only 2 games in the war-shortened season, going 0-1 in seven innings of work. He went on to win 11 games for the Brewers against 17 losses through 1921. (From the collection of Bob Koehler.)

KINSEY KIRKHAM (1919–1921). The outfielder began his career with Milwaukee 1919 when he batted .271 in 335 at-bats. During his next two seasons with the Brewers, he averaged .291 at the plate. He never made it to the big show. (Photo from the collection of Bob Koehler.)

MILWAUKEE, AMERICAN ASSOCIATION, BASE BALL CLUB, MILWAUKEE, WIS.
1, Rhinehart; 2, Miller; 3, Staylor; 4, Brielmier; 5, Luskey; 6, Bues; 7 Gearin; 8, Ulrich; 9, Northrup; 10, Hauser; 11, Elyan; 12, Huhn; 13 McWeeney; 14, Gaston; 15, Mastel; 16, Butler; 17, Conney.

THE MILWAUKEE BREWERS OF 1920. This team photo of the sixth-place Brewers shows Joe Hauser along with other Brewer standouts Emil Huhn (1b/c), Art Butler (2b), outfielder Johnny Mostil (incorrectly spelled "Mastel") and pitcher Jake Northrop (misspelled as "Northrup"). Number 17 "Conney" is Jimmy Cooney (ss). Other misspellings are: Pitcher Art Reinhart as "Rhinehart"; outfielder Ray Brielmaner as "Brielmier"; infielder Walter Lutzke as "Luskey"; pitcher Doug McWeeny as "McWeeney". The other names are: Ed Miller (p), Chuck Staylor (c), Dennis "Dinty" Gearin (p), Frank Ulrich (c), and Alex Gaston (c). Emil "Hap" Huhn was killed instantly in an automobile accident on September 5, 1925, ten miles north of Camden, South Carolina. He was 33. (Photo from the *Reach Official American League Guide* for 1920 in the collection of Rex Hamann.)

MILWAUKEE NATIVE "UNSER CHOE" JOE HAUSER (1920–1921; 1929). Shown here as a Minneapolis Miller (*circa* 1935), Joe "Zips" Hauser made his American Association debut as a Milwaukee Brewer, taking on outfield duties (and pitching in one game). "Choe" clobbered a team high 15 homers in 1920 while hitting .284 with 22 doubles and 16 triples for the sixth-place Brewers. He would go on to have a stellar career with the Philadelphia Athletics before returning to the high minors with the Baltimore Orioles of the International League. He wrapped up his professional baseball career in supreme fashion as a Minneapolis Miller (1933–1936), where he set the minor league record for home runs in a season with 69 in 1933. (Courtesy of Neal Rink, from the collection of Rex Hamann)

MAYOR DANIEL WEBSTER HOAN. One of a string of socialist mayors in Milwaukee during the first half of the twentieth century, Hoan was known more for his approach to politics than his acumen upon the ball field. In this 1923 photograph, the honorable mayor winds up and delivers the opening pitch on the Brewers' 22nd Opening Day at venerable Athletic Park. Hoan was elected the mayor of Milwaukee in 1916 and held that position for 24 years. (From the collection of Bob Koehler)

DINTY "KEWPIE" GEARIN (1920–1931). Dennis John Gearin, born October 15, 1897, at Providence, Rhode Island, was one of the all-time long-tenured Brewers pitchers. Gearin played for Milwaukee from 1920 to 1931. Frequently doing double duty as an outfielder, Gearin was known as a capable stick-handler. His no-hitter on August 21, 1926, against Columbus was the Brewers' first since Joe Hovlik completed the stellar task in 1912. Gearin's best season for the Brewers was in 1923 when he won 12 games against 5 losses with an ERA of 3.76 in 153 innings of work; his .337 batting average was surprising for a pitcher. The 5'4" southpaw hit over .300 on four occasions during his 12-year Milwaukee term. Iin 1922 he hit .350 in 117 at-bats while compiling a won-loss record of 11-12. (From the collection of Bob Koehler)

JIMMY COONEY (1920–1924). In this photo (*circa* 1924) Brewer shortstop Jimmy "Scoops" Cooney wears the woolens at Brewer Field. Cooney spent five seasons in Milwaukee, ending in 1924. His best season was in 1923 when he combined a .308 batting average with 92 RBIs and 96 runs in 600 at-bats. And, let's not forget his SIXTY stolen bases, the league leader and the most in Brewer history (breaking the team record of 48 originally set by Germany Schaefer in 1904 and tying the team mark set by the famous American Indian athlete Jim Thorpe in 1916). Cooney played in seven seasons for various teams at the major league level from 1917 to 1928. (From the collection of Bob Koehler.)

VIRGIL BARNES (1921). Owning the Brewers' leading ERA of 4.24 in 1921, Barnes compiled 17 wins against 15 losses, topping the club with 117 strikeouts in 259 innings in his only season as a Brewer. Barnes had a lengthy career with the New York Giants during the 1920s. (From the collection of Bob Koehler.)

NIG CLARKE (1921). The veteran Canadian catcher was acquired by Milwaukee on April 26, 1921, from Toledo. At the age of 38, Jay Justin "Nig" Clarke appeared in 75 games for Milwaukee, batted .272 and drove in 42 runs. His major league career spanned from 1905 to 1920. (From the collection of Bob Koehler.)

George "Chippy" Gaw (1921). After pitching in six games for the Chicago Cubs in 1920, Gaw came to Milwaukee where he won five games and lost nine while racking up an ERA of 4.93 in 104 innings. (From the collection of Bob Koehler.)

Dick (John) Gossett (1921–1923). One of the few catchers in the American Association with a total AA career including ten or more seasons, Gossett joined the Brewers in 1921 after seven stints with Indianapolis. Appearing in 49 games for the New York Yankees from 1913 to 1914, his best year in Milwaukee was in 1922 when he raised his previous year's batting average 61 points to .338 in 219 at-bats while catching 72 games. Gossett's mark of seven homers was a career high. He skipped the team after appearing in 18 games in 1923. Gossett is buried at Rose Hill Memorial Cemetery in Massillon, Ohio, where he died in 1962. (From the collection of Bob Koehler.)

DINTY GEARIN AND BOB TRENTMAN. This photograph (*circa* 1921) is a study in perspective. Gearin, in his second year in Milwaukee, earned 14 wins against 11 losses in 215 innings, while his pal Bob Trentman, in his third year, brought five wins home against 7 losses. Trentman's best year with Milwaukee was in 1920 when he won 6, lost nine, and had a 4.74 ERA in 167 innings. Gearin had a few cups of coffee in the majors while Trentman never made it to the bigs as a pitcher. (From the collection of Bob Koehler.)

VIEW FROM CENTER FIELD. Here is an early perspective (*circa* 1910) from the camera at Athletic Park in Milwaukee. The outer grandstands were later roofed in. (courtesy of the Milwaukee Public Library.)

HARRY CLARK WITH BREWERS' OWNER OTTO BORCHERT. Player/manager Harry Clark looks dapper sitting alongside his boss Otto Borchert, the affable owner of the Milwaukee Brewers (1920–1927), in this *circa* 1924 photo. (Photo courtesy of Bob Koehler.)

WID MATTHEWS (1921–1922; 1924). During his first of three seasons with Milwaukee, "Matty" Matthews played the outfield for 94 games, hitting .338 and stealing 30 bases. He also played for the Philadelphia Athletics and Washington Senators from 1923–1925 and became the general manager for the Chicago Cubs after the 1949 season. (From the collection of Bob Koehler.)

FRED SENGSTOCK (1921–1922). Hitting .284 in 46 games, Sengstock performed catching duties for Milwaukee in 1921 and appeared in only ten games the following season. (Photo from the collection of Bob Koehler)

ALEX MCCARTHY (1921–1925). The Brewers' regular third-baseman hit .283 during his first season with Milwaukee. McCarthy's cumulative Milwaukee batting average was .286 with 795 hits in 2,782 at-bats. He joined the Brewers after an eight-year major league career with both the Pittsburgh Pirates and the Chicago Cubs from 1910 to 1917. Note the uniform number sleeve patch, *circa* 1925. (Photo from the collection of Bob Koehler.)

Three
From Gearin and Griffin to Gerken and Gullic
1922–1931

From 1922 through 1931 the Brewers played host to many talented players, yet they seemed to be fighting gravity as they grappled with their fellow American Association teams. Improving under Clark to fifth place in 1922, with the likes of Ivy Griffin batting .303 and Nelson Pott winning 15 games against 10 losses, the Brewers had added some potency to their line up. Consider Glenn Myatt, fresh off a two-season stint as the backstop for the Athletics of Philadelphia, and his unlikely hitting explosion for Milwaukee. In 370 at-bats, Myatt racked up 137 hits for a .370 batting average. He learned how to hit during his one-season stay in Milwaukee. Picked up by the Cleveland Indians in 1923, Myatt starred for the Tribe throughout the remainder of the decade. Clark could do no better than fourth place with his Suds Boys in 1924.

Enter Jack Lelivelt to manage the team. Once a strong hitting outfielder in the majors (1909–1914), the Chicago born ballplayer previously performed for half the teams in the AA—playing first-base or outfield with the Cleveland Spiders, Kansas City Blues, Louisville Colonels and Minneapolis Millers—before coming to Milwaukee to manage in 1926. Under Lelivelt the Brewers rose to third place in the standings, followed by a serious run at the AA pennant in '27 when they tied with Louisville for second place (99-69), just two games behind the surprising Toledo Mud Hens under Casey Stengel. In 1929, his final season with Milwaukee, Lelivelt left the club after 59 games and a club record of 21-37 with one tie as the Suds Busters barreled into seventh place.

There were extenuating circumstances surrounding the club's activities during their third decade of existence. At the age of 52, club owner Otto Borchert died suddenly while giving a speech before the Elks Club in Milwaukee on April 27, 1927, just days before the start of the season. Brewer players wore black armbands all season in his honor. Then in 1929, the passing of Henry Killilea on January 23 was mourned by the Milwaukee community. Killilea was a longtime Milwaukee man who had owned the Milwaukee Brewers of the Western League some 30 years prior. He was Ban Johnson's right-hand man during the establishment of the American League in 1901. Again, the players wore the customary black band on their sleeve in honor of Killilea.

The Depression impacted the Brewers' gate receipts as a drastic drop in attendance was evident, but the club's trials at the turnstiles had started the year before, when the gate receipts dropped from 307,374 in 1928 to 156,340 in 1929. A fifth place finish in 1932 saw a somewhat puzzling increase at the gate when 235,545 visitors came to see their Brew Boys in action.

ART "TINK" RIVIERE (1922). After pitching for the St. Louis Cardinals (1-0, 18 games), Riviere came to Milwaukee and posted a 10-10 record with a 5.00 ERA in 32 games and 142 innings of work. (From the collection of Bob Koehler.)

OSCAR "SKI" MELILLO (1921–1925). Also known as "Spinach", Melillo used Borchert Field as a launching pad on his way to a respectable American League career as a St. Louis Brownie. As a Brewer, he debuted as an outfielder in 1921 (one game in left-field), then converted to the second sack in 1923. Ski's best year was his last with Milwaukee as he occupied the keystone sack in 152 games, hitting .294 with 13 home runs and 118 RBIs in 1925. (From the collection of Bob Koehler.)

DAVE KEEFE (1922–1924). Not one of the Brewers' brightest stars, Keefe had a cumulative won-loss record of 13-29 in his three years with Milwaukee, with an ERA to match, from 1922 to 1924. (From the collection of Bob Koehler.)

CROWD ASSEMBLING FOR OPENING DAY GAME, 1922. Is there one man among the crowd without a hat on? Some folks arrived at the game at Milwaukee's Athletic Park in motor driven vehicles. From the looks of this walkup crowd, a good gate was in store for this home opener on a sunny day in 1922. (From the collection of Bob Koehler.)

1, Bigbee; 2, Lear; 3, Lingrel; 4, Schneider; 5, Myatt; 6, Clarke; 7, Griffin; 8, Johnson 9, Riviere; 10, Cooney; 11, Schultz; 12, Lober; 13, Gossett; 14, Pott; 15, Mellilo 16, Clark; 17, McCarthy.
Baker Art Gallery, Photo

The 1922 Milwaukee Brewers. Again possessing the fifth position in the American Association standings at 81-86, the Brewers landed 22½ games behind the St. Paul Saints (107-60) under manager Harry "Pep" Clark, who returned to pilot the Brewers after a five-year hiatus. The Brewers welcomed 214,892 through the gates of Borchert Field, eclipsing their earlier mark from 1913 for the second best mark since attendance records were first kept in 1908. Milwaukee's regular catcher Glenn Myatt took the AA batting championship with his .370 batting average in 370 at-bats while smacking a team-high 16 triples. (A Baker Art Gallery photo from the collection of Bob Koehler.)

Pitching Duo Dinty Gearin and Bob Clarke (1922). Dennis "Dinty" (aka "Kewpie") Gearin (left), in his third year with the Brewers in 1922, poses for the camera with Bob Clarke. Gearin's record was 11-12 with an ERA of 4.27 in 177 innings, appearing in 31 games while Clarke went 9-5 with an ERA of 5.90 in 157 innings, taking the mound in 40 games in his only season with Milwaukee. (From the collection of Bob Koehler.)

ENOCH "GINGER" SHINAULT (1923–1924; 1930). The Brewers' regular backstop in '23, Shinault appeared behind the plate in 134 games, hitting .297 with 20 doubles and 12 triples. He returned in '24 when he platooned with youngster Russ Young. (From the collection of Bob Koehler)

BOB CLARKE (1922). Clarke finished with an impressive 9-5 record in 157 innings with the 1922 Brewers, but his 5.90 ERA shows he hadn't yet adjusted to the live-ball era. As a hitter his performance was remarkable with a .339 batting average in 62 at-bats. (From the collection of Bob Koehler.)

JIM LINDSEY (1923). After compiling a record of 4-5 for the Cleveland Indians in 1922, the right hander came to Milwaukee where he put together a record of 8-12 and a 4.79 ERA in 142 innings of work for Clark's crew in 1923. (From the collection of Bob Koehler)

JOE EDDLEMAN (1924–1929). In his six years with Milwaukee, Eddleman won a total of 69 games against 65 losses, giving testimony to his standing as a long-tenured Brewer pitcher. With a 5-2 record during the 1924 season, he was just getting started. His best season was only a few years off, as he won 21 games against only 10 losses during the Brewers' thrilling pennant chase of 1927, when his ERA was 4.23 after pitching 266 innings under manager Jack Lelivelt. (From the collection of Bob Koehler.)

RUSS YOUNG (1923–1930; 1932–1934). The longtime Brewer catcher appeared in over 800 games in a Milwaukee uniform from 1923 to 1934, compiling a career batting average of .284. His most productive season (combining offensive and defensive output) came in 1933 when he bore the "tools of ignorance" in 113 games and hit .302 in 417 official at-bats, smacking 20 doubles and driving in 72 runs. His high career batting average came in 1930 when he tallied a .312 average in 365 at-bats, appearing in 84 games as catcher and 15 at the first sack. All tolled, the Ohio native appeared in 870 American Association games through ten seasons, nearly all of which were with the Brewers. He landed in Minneapolis midway through the 1934 season. (From the collection of Bob Koehler.)

SHERRY MAGEE (1923–1925). In his first season as a Brewer, the 38-year-old Magee played the outfield and showed up for 48 games, hitting .332 and stealing nine bases. But Magee was no rookie; he performed in 16 major league seasons from 1905 to 1919 with a .291 career batting average, most notably with the Philadelphia Phillies. Magee is listed among the 400 Greatest Players in *Total Baseball*. He made the most of his last years in baseball by hitting .333 for the Brewers in 414 at-bats. Sherwood Robert Magee died in Philadelphia on March 13, 1929, just a few years after his baseball career in Milwaukee was over. Note uniform number patch in this *circa* 1925 photo. (From the collection of Bob Koehler.)

PAT MCNULTY (1923). After appearing in 22 games with Cleveland in 1922, McNulty came to the Brewers as an outfielder, contributing a .313 batting average in 480 at-bats and stealing 24 bases under manager Harry Clark. (From the collection of Bob Koehler.)

A FEARSOME THREESOME. Oscar Melillo, Paul Johnson (1922–1924) and Pat McNulty are pictured here at Borchert Field in this photo from 1923. The Brewer trio combined for 224 runs, 397 hits, and 176 RBI against American Association pitchers as the Brewers landed in fifth place under Harry Clark with a record of 75-91. (From the collection of Bob Koehler.)

THE 1923 HOME OPENER IN MILWAUKEE. This photo depicts the first play of the Brewers' 1923 home season. Batting is first baseman Ted Jourdan of the Minneapolis Millers. The Brewer backstop is Enoch "Ginger" Shinault, with umpire Connally looking on. (From the collection of Bob Koehler.)

THE 1924 MILWAUKEE BREWERS. Manager Harry Clark's Brewers finished with a .500 record of 83-83 during the 1924 American Association campaign. This photo was probably taken at Neil Park in Columbus, Ohio. From left to right: (front row) Harry Strohm (3b/2b), Lester Bell (ss), Harry Clark (mgr.), Alex McCarthy (3b), Ted Pritchard (p), and Lance Richbourg (of); (middle row) Man in straw hat is unidentified, Elmer Lober (of), Russ Young (c), George Winn (p), Ed Schaack (p), Oscar Melillo (2b), Paul Johnson (of), Ivy Griffin (1b), and Frank McGowan (of); (back row) Roy Walker (p), Ginger Shinault (c), George Walberg (p), Sherry Magee (of), and Bob McMenemy. The mascot is unidentified. (Courtesy of Lance Richbourg, Jr.)

GEORGE "RUBE" WALBERG (1924). Leading the team in wins with 18, Walberg struck out 175 of the opposition to top the American Association in his only year of action for the Brewers. Tied with the team lead in innings pitched (245) with Nelson Pott, Walberg's healthy ERA of 3.78 carried the starting staff. (From the collection of Bob Koehler.)

LANCE RICHBOURG (1924–1926). Most notable for his years with the Boston Braves (1927–1931), the Florida fly-flagger wandered the outfield as a 26 year old during his 1924 debut with the Brewers, hitting 33 doubles while batting .321 in 121 games. Richbourg's 28 triples in 1926 led the American Association, tying him with Louisville's Bert Daniels (1915) for the all-time American Association record. (From the collection of Bob Koehler.)

FRANK "BEAUTY" MCGOWAN (1924). Gracing Brewer Field (*aka* Athletic Park) for a single season, the outfielder made a name for himself in Milwaukee with his 14 homers and .291 batting average in 490 at-bats. (From the collection of Bob Koehler.)

THE MILWAUKEE BREWERS OF 1925. Manager Harry Clark's final year in his extensive career with the Brewers resulted in 74 wins against 94 losses as his team finished in seventh place. This was the first year that the Brewer offense would be catapulted by the legendary Bunny Brief, who hit .358 and belted out 37 homers. From left to right: (front row) Lance Richbourg (rf), George Armstrong (3b), Alex McCarthy (ss), Harry Clark (mgr.), Roy Walker (p), Oscar Melillo (2b), Frank Luce (lf), and Otto Borchert (owner); (back row) Harry Strohm (2b), Fred Schulte (cf), Bill Skiff (c), Herman "Hi" Bell (p), Bunny Brief (lf), Ivy Griffin (1b), and Earl Schneider (p). The team's longtime trainer, George Washington Buckner ("Old Buck" or "Doc") is numbered 16 behind the grating. With the team largely in tact from 1925, the Brewers went on a winning binge during their 1926 campaign in the American Association with 21 straight victories, a league record. (Courtesy of Lance Richbourg, Jr.)

TAYLOR DOUTHIT (1925). Splitting the 1925 season with the St. Louis Cardinals, the 24-year-old Douthit played in 92 games as an outfielder in Milwaukee, leaving no room for doubt as to his hitting credentials with his .372 average and 10 homers in 376 at-bats. Back at St. Louis the following year, he hit .308. Douthit ended his major league years with the Chicago Cubs in 1933, a career .291 hitter. (From the collection of Bob Koehler.)

FRANK LUCE (1924–1929). After one season in the bigs with Pittsburgh in 1923, Luce's career as a Brewer came without fanfare during his first year in 1924 (he has no offensive record). But he quickly established himself as a hitter in '25, appearing in 123 games and hitting .315 in 384 at-bats with a team second 14 home runs. The following year Luce saw limited playing time, appearing in 78 games but showing resiliency at the plate by producing a .360 batting average in 178 official trips. In 1927 he regained a spot in the regular lineup and stayed there through the 1929 season, earning the nickname "Powerhouse" along the way by accumulating a career AA .322 batting mark in over 1,900 at-bats and smashing over 60 home runs. (From the collection of Bob Koehler.)

BUD CONNOLLY (1925; 1931–1933). Also known as "Mike," Connolly first joined the Brewers for a 46-game stint in 1925, splitting the season with the Boston Red Sox. He returned to the Brewers in 1931 where he filled the second base spot through the 1933 season. Connolly excelled in 1931 when he hit .315 in 670 at-bats. He was known to winter aboard seagoing freighters sailing to African ports during the off-season. (From the collection of Bob Koehler.)

GEORGE ARMSTRONG. Appearing in his only season as a Brewer. In 1925, Armstrong covered the hot corner in 54 games while appearing in 72 games overall, hitting .258 for the seventh-place Milwaukee Men. (From the collection of Bob Koehler.)

OVID MCCRACKEN (1925–1926). The pitcher appeared in 46 games for the Brewers in 1925, tallying a record of 4-11 with an ERA of 5.21. In '26 he appeared in six games with no decisions. (From the collection of Bob Koehler.)

ROY L. SANDERS (1925–1928). Milwaukee's third-winningest pitcher with 15 wins in 1925, "Simon" Sanders carried a weighty 5.82 ERA while losing 16 in 50 games pitched. He improved his record to 14-11 the following year while dropping his ERA to 4.38 in 46 games, the best of his four seasons with the Brewers. (From the collection of Bob Koehler.)

Ralph Miller (1925). At the age of 29 the shortstop's major league career was over, but the Brewers brought him on board for one season and Miller did not disappoint. His .311 average in 389 at-bats, 15 doubles, and 59 RBIs were enough to give him an edge over Bud Connolly who hit .302 while platooning with Miller at short. (From the collection of Bob Koehler.)

Clyde "Jersey" Beck (1926). As a 26-year old second sacker, Beck debuted with both the Brewers (55 games, .282 average) and the Chicago Cubs (30 games, .198). The prototypical journeyman infielder from California had his best season in '27 with Chicago, where he proved he could hit major league pitching by raising his average to .257. (From the collection of Bob Koehler.)

DAVE DANFORTH (1926–1927). Joining the Brewers at the age of 36, southpaw "Dauntless Dave" won 17 games against 15 losses and an ERA of 3.92 for the third-place Brewers. The six-foot Texan completed a Texas-sized 273 innings in 43 games, striking out 123 batters against 74 walks. He appeared in only seven games (125 innings) in '27. (From the collection of Bob Koehler)

JACK LELIVELT (1926–1929). The Brewer manager tallied a composite record of 303-255 (.543) during his four-year term in Milwaukee. Lelivelt ranks fourth, seventh, and eleventh among Brewer managers with the most wins in a single season: 99 in 1927, 93 in 1926, and 90 in 1928. He died on January 20, 1941, in Seattle, Washington. (From the collection of Bob Koehler.)

OSSIE ORWOLL (1925–1927; 1929). While not appearing in earnest until the 1926 season, Orwoll was 24 years old when he first joined the Brewers. In his first full season, the versatile left hander took the mound for Milwaukee in addition to filling in as an outfielder in 26 games, batting .287 in 181 at-bats, clubbing 3 homers, and driving in 42 runs. With 12 wins against four losses he earned the best winning percentage on the team at .750; in 168 innings of work, he also had a respectable ERA 4.07 in his debut season. (Photo from the collection of Bob Koehler.)

BOB MCMENEMY (1924–1929). In his first full season catching for the Brewers, McMenemy's bat did the talking. Appearing in 113 games, he earned a .351 batting average in 342 at-bats. (From the collection of Bob Koehler.)

CHARLIE ROBERTSON (1926; 1929–1930). A former Chicago White Sox pitcher, Robertson showed his stuff in Milwaukee, capturing 12 wins against 5 losses in 146 innings, flashing the staff's best ERA of 3.38. His success led to his premature departure from the team, as he joined the St. Louis Browns for eight games later in the season. (From the collection of Bob Koehler.)

"NOW PLAYING IN RIGHT FIELD . . ." Bozo, the public address announcer at Brewer Field, uses his megaphone to address the crowd, *circa* 1925. (From the collection of Bob Koehler.)

SYLVESTER "SYL" SIMON (1926). Hitting an impressive .308 while taking hot-corner duties for the Brewers, Simon appeared in 107 games in his only season with Milwaukee. (From the collection of Bob Koehler.)

LLOYD FLIPPIN (1926–1927). Hitting .231 as the Brewers' regular shortstop in 381 at-bats over 121 games, Flippin scavenged 51 walks while striking out only 21 times. This photo is dated May 26, 1926, and was likely taken at St. Paul's Lexington Park. (From the collection of Rex Hamann.)

GEORGE GERKEN (1927; 1930–1932). The outfielder's best season as a Brewer was in '27 as a regular in the Brewer Field pastures when he hit .297 with 12 homers and 62 runs driven in. (From the collection of Bob Koehler.)

WALTER BECK (1927). Shown here warming up before a game at Brewer Field, Beck pitched in only five games for Milwaukee and obtained an 0-1 record. His black armband was worn by each of the Brewer players in honor of the recently deceased Brewer owner Otto Borchert. (From the collection of Bob Koehler.)

ROY ELSH (1927). The outfielder appeared in 45 games for Milwaukee, earning a batting average of .280 in 157 at-bats. (From the collection of Bob Koehler.)

RUSS YOUNG AND MARTY BERGHAMMER (1927). The Brewer catcher listens attentively to instruction from manager Jack Lelivelt during warm-ups at Brewer Field. (From the collection of Bob Koehler.)

HANK JOHNSON (1927). An 18-game winner for the Brewers, Johnson was another cog in the Brewers' pitching machinery which nearly brought them an AA pennant in '27. He ended up with a few successful years in the New York Yankee organization, in addition to other teams in his 12 seasons in the majors. (From the collection of Bob Koehler.)

HARRY RICONDA (1927). After a few years at the major league level, Riconda became a regular in the Brewer infield, assuming the shortstop position for 105 games and filling in at second base in 62 games. His 722 at-bats topped the league and he made the most of it by racking up 255 hits (a league-topper), stroking a yeoman-like .353 batting average on his way toward setting the all-time Brewer record of 57 doubles, another top mark in the American Association for 1927. Riconda's 18 triples also led the team. (From the collection of Bob Koehler.)

THE OFFICIAL BASEBALL SCORE CARD. This format for the display of daily scores of locally significant baseball results was presented through the Milwaukee printing company B.F. Steinel Publishing Company during the 1920s, continuing a long tradition of such advertising. In this example, Milwaukee defeated Toledo on June 14, 1927, by a score of 6-3 at Toledo's Swayne Field. The Brewers featured pitcher Claude "Bubber" Jonnard with Bob McMenemy catching. Toledo's battery included Ernie Maun on the mound with Luther Urban receiving. (From the collection of Rex Hamann.)

CEREMONY AT BREWER FIELD. This photo was probably taken shortly after the death of Brewers' owner Otto Borchert. The park was not officially named "Borchert Field" until sometime after the passing of Mr. Borchert, probably in 1928. Jack Lelivelt accepts what appears to be a cigar or jewelry box. Members of the Columbus Senators are present. (From the collection of Rex Hamann.)

HERSCHEL BENNETT (1928). Outfielder in 107 games for the Brewers in 1928, hitting .277 in 452 at-bats, Bennett was previously a member of the St. Louis Browns for five seasons. (From the collection of Bob Koehler.)

BILL BATCH (OR BATSCH) (1928). Mr. Batch sealed the hatch at the second-sack in 48 games for Milwaukee, hitting .292 in 1928. (Photo from the collection of Bob Koehler)

CLAUDE JONNARD (1926–1928; 1931). "Bubber" finished the 1928 season with a mark of 20-11 and led the American Association in strikeouts with 150. (From the collection of Bob Koehler.)

IVY GRIFFIN (1922–1929). The Brewers' regular first-baseman, Griffin shows his athletic form in this 1927 photo. Hitting a career high .362 in 1923, one of the best averages in Brewer history, Griffin was a perennial .300 hitter during his tenure with Milwaukee. He died at the age of 59 in an automobile accident on August 25, 1957, near Gainesville, Florida, while acting as a baseball scout. (From the collection of Bob Koehler.)

BEVO LEBOURVEAU (1928–1929). The legendary LeBourveau was one of the American Association's greatest players with his .358 career batting average, including 81 homers, 238 doubles, 633 RBIs and 194 stolen bases in ten seasons (3,773 at-bats) from 1924 to 1933. Coming to Milwaukee in 1928, he quickly made an impression on Milwaukee fans by hitting a staggering .399 in 266 at-bats as an outfielder, the best mark for a Brewer (250 plus at-bats) since George Stone's .405 in 1904. The following year he came down to earth at .329 in 416 at-bats. Bevo was born DeWitt Wiley LeBourveau in 1894 at Dana, California. (From the collection of Bob Koehler.)

OTTO "OTIS" MILLER (1928–1929). After 51 games with the St. Louis Browns during the 1927, Miller came to Milwaukee and hit .314 in his first year with the team while taking care of business at shortstop (107 games), second-base (19 games) and in the outfield (17 games). He then smacked a team-second 35 doubles in 1928, appearing in a total of 149 games. (From the collection of Bob Koehler.)

TOM "BLACKIE" (*aka* "TUT") JENKINS (1929–1930). In his debut year with the Brewers, Jenkins hit a cool .329 in 401 at-bats while roaming the outfield. In his final year as a Brewer the following season, he sizzled at the plate with a .345 average in 626 at-bats! Blackie formerly played for Boston (AL) and Philadelphia (AL), and did double duty between Milwaukee and the St. Louis Browns in 1929 and 1930 before rejoining St. Louis from 1931 to 1932. (From the collection of Bob Koehler.)

EDDIE GRIMES (1929–1930; 1933). The Brewers' regular shortstop in 1929, Grimes appeared in 160 games, hitting .285. He returned to Milwaukee for the 1930 season and led the league in at-bats with 670, hitting at a .291 clip. He also topped the team with 121 runs and 15 stolen bases. Moving on to St. Louis as a member of the Browns from 1930 to 1931, he found himself again at Borchert Field in '33 when he appeared in 86 games at shortstop and hit .246. (From the collection of Bob Koehler.)

MARTY BERGHAMMER. During the first of three stints as the Milwaukee field general, Berghammer piloted his Brewers to a record of 46-59 after the departure of Jack Lelivelt (21-37) in '29. Taking the reigns in 1930, "Pepper" needed a little salt for his Brewers who landed in seventh-place with a 63-91 record. The following year he appeared to have the right recipe in bringing the team to a 50-53 record, but a new opportunity arose and he was replaced by Frank "Blackie" O'Rourke. (From the collection of Bob Koehler.)

HERB COBB (1929–1931). In 1929, the pride of Pinetops, North Carolina joined the ranks of the Milwaukee Brewers. Taking the mound at Borchert Field during his debut year, Cobb pitched in 40 games, winning 14 while giving up 17 decisions. His 5.73 ERA is forgettable, but so were all the Milwaukee ERAs in '29. The following year, he appeared in only 59 innings in ten games, going 4-4. He was used even more sparingly in '31. (From the collection of Bob Koehler.)

ED STRELECKI (1929–1930). The right-hander appeared in 28 games (7-11, 4.50 ERA) during his first year in a Brewer uniform. In 1930, he took the mound in 42 games for Milwaukee, topping the list, winning 13 games against ten defeats in 215 innings. (From the collection of Bob Koehler.)

ROSY RYAN (1929–1930). After nine major league seasons, Wilfred "Rosy" Ryan entered the American Association as a pitcher in 1926 with Toledo before coming to Milwaukee in '29. He is pictured here as a Minneapolis Miller, a team he would later manage. In his Milwaukee debut season, Ryan was the team workhorse, accumulating 258 innings of work which resulted in 15 wins for the seventh-place Brewers in 1929. He led the team in strikeouts with 100, appearing in 43 games. (From the collection of Bob Koehler.)

STAN BENTON (1930). Hitting .307 for Milwaukee in 62 games with 163 at-bats, the shortstop played the field in 38 games in 1930. (From the collection of Bob Koehler.)

JOHN BUVID (1929–1931). The pitcher began his Milwaukee career in 1929 when he won nine games against six losses with an ERA of 5.29. In '31 he appeared in only five games. (From the collection of Bob Koehler.)

DAN BLOXSOM (1930–1931). Hitting .321 during his rookie season as a Brewer, Bloxsom slammed 29 homers while covering the hot-corner through 134 games. But he couldn't carry the potent bat into the 1931 season when he appeared in 72 games and hit only .258 in 260 at-bats. Bloxsom never played in the majors. (From the collection of Bob Koehler.)

WALTER "CUCKOO" CHRISTENSEN (1930–1933). In his first year with the Brewers at the age of 30, "Cuckoo" went nuts with the stick, hitting .362 in 315 at-bats in 1930, .325 in 215 at-bats in '31, and .325 in 428 at-bats in '32. His "decline" came in 1933 when the outfielder finished his tenure in Milwaukee with a .307 average, playing in 132 games. (From the collection of Bob Koehler.)

MERV SHEA (1930–1931). Shea hit .250 in the catcher's role during his first year in Milwaukee. He played in the majors during 11 seasons from 1927–1944 with various teams. (From the collection of Bob Koehler.)

JIM "CHAPPIE" GEYGAN (1929–1930). Coming to Milwaukee from Columbus in 1929, the second baseman saw limited action as a Brewer in '30, appearing in only six games and compiling a .333 average. Geygan died in 1966 and is buried at St. Michael's Cemetery just south of the city of Columbus, Ohio. (From the collection of Bob Koehler.)

GEORGE "BUCK" STANTON (1930; 1932–1933). The Brewers' regular first baseman in 1930, Stanton tallied a .321 average in 504 at-bats while driving in 96 runs. He resumed his career in Milwaukee in 1932 when he covered the first sack in 161 games and earned a .291 average with team leads in runs (131), hits (194) and triples (16). The Brewers welcomed him back in '33 when he again posted excellent numbers, duplicating his previous .291 average and leading the club in RBIs (87) and doubles (33), which tied him with Bud Connolly. His 15 stolen bases also topped the team. (From the collection of Bob Koehler.)

OSCAR STARK (1930). Stark appeared in 19 games for the 1930 Brewers, compiling a record of 0-3 in 44 innings, but never made it to the bigs. (From the collection of Bob Koehler.)

FRED STIELY (1930–1933). Appearing in 26 games during his first year in a Milwaukee uniform, the lefty had an 11-12 record and the team's best ERA (4.19) in 193 innings. Stiely stayed with the Brewers through 1933. (From the collection of Bob Koehler.)

EUGENE "PETE" TURGEON (1930–1931). Turgeon posted a .319 average during his first year as a Brewer, covering the keystone sack and pitching in one game. (From the collection of Bob Koehler.)

WAYNE WINDLE (1930). Covering second base and shortstop in 70 games, Windle hit .257 as a Brewer with four homers and 28 runs driven in. (From the collection of Bob Koehler.)

THE MILWAUKEE BREWERS OF 1930. Marty Berghammer remained the skipper of the Brewers for the 1930 season as the nation headed into its first year of a severe economic depression. The gate receipts reflected a downward turn, as Borchert Field's aggregate attendance of 142,701 ranked fifth in the American Association. The Milwaukees came up with 63 wins against 91 losses, finishing in seventh place, 30 ½ games behind the Louisville Colonels. From left to right: (front row) Stan Benton (ss), Dan Bloxsom (3b/ss/of), Marty Berghammer (mgr.), Wayne Windle (2b/ss), Walt "Cuckoo" Christensen (of), and John Buvid (p); (middle row) Wilfred "Rosy" Ryan (p), Charlie Barrer (p), Fred Stiely (p), Merv Shea (c), Ed Strelecki (p), George "Buck" Stanton (1b), and Fred Bennett (of); (back row) Dennis "Dinty" Gearin (p), Ed Grimes (3b/ss), George Gerken (of), Tom Jenkins (of), Russ Young (c), and Charlie Robertson (p).(Photo by the Baker Art Gallery, *The Spalding Official Base Ball Guide* in the collection of Rex Hamann.)

STIELY IS MASTER OF KAYSEES UNTIL THE FINAL INNING

Fred Is Touched for Two Runs in Ninth Session and Then Gives Way to Nelson

By RED THISTED.

The Brewers won the opening game of the series with the nigh stepping Kansas City Blues at Borchert Field Saturday afternoon, 6 to 4. Fred Stiely was manager O'Rourke's selection for mound duty and the southpaw ace held the Blues to one lone hit for the first six frames. He was replaced by Nelson in the ninth when the visitors scored a pair of runs on four hits.

Milwaukee scored once in the second inning and three more runs crossed the plate in the fourth on five hits. The Brews tallied again in the eighth with another pair. Kansas City did not count a run until the seventh. They scored another in the eighth on two doubles, and threatened the Brewer lead in the ninth with two runs and four hits.

Pip Koehler made his bow in a Brewer uniform in the eighth when he batted for Kubek, but the best he could do was ground out to the infield.

FIRST INNING.

KANSAS CITY—Boken grounded to Shires. Marquardt and Pick flied to Metzler. No runs, no hits, no errors.

MILWAUKEE — Tavener took two bases when Grigsby dropped his short fly. Fette threw out O'Rourke. Connolly was thrown out by Dugas, Tavener going to third. Marquardt tossed out Haas. No runs, no hits, one error.

SECOND INNING.

KANSAS CITY — Monahan singled to right. Ackers walked.

Our Boys!

MILWAUKEE.	AB	R	H	PO	A	E
Tavener, ss.	5	0	1	2	3	2
O'Rourke, 3b.	3	0	0	2	3	0
Connolly, 2b.	4	0	1	2	2	0
Haas, lf.	4	3	2	12	0	0
Shires, 1b.	4	0	1	0	0	0
Metzler, cf.	4	2	2	5	0	0
Kubek, rf.	1	0	0	0	0	0
Koehler, rf.	1	0	0	0	0	0
Crouch, c.	3	0	2	4	0	0
Stiely, p.	4	1	2	0	2	0
Nelson, p.	0	0	0	0	0	0
Totals	33	6	11	27	10	2

KANSAS CITY.	AB	R	H	PO	A	E
Boken, 3b.	5	0	0	1	3	0
Marquardt, 2b.	3	0	1	3	4	0
Pick, lf.	4	0	0	0	1	0
Monahan, 1b.	4	0	1	14	0	1
Ackers, ss.	3	2	2	1	5	0
Grigsby, cf.	3	1	1	4	0	1
Dugas, rf.	4	0	0	0	0	0
Peters, c.	4	0	0	0	0	0
*Jayne	0	0	0	0	0	0
Fette, p.	1	0	0	1	8	0
Thomas, p.	2	1	1	0	2	0
†Padden	1	0	1	0	0	0
Totals	34	4	7	24	23	3

*Ran for Peters in ninth.
†Batted for Thomas in ninth.

Kansas City......... 0 0 0 0 0 0 1 1 2—4
Milwaukee 0 1 0 3 0 0 0 2 x—6

Runs batted in—Crouch 2, Metzler, Tav-

GAME REPORT AND BOX SCORE. This is a detailed report of a baseball game at Borchert Field from September 5, 1931, when the Brewers encountered the Kansas City Blues. It typifies the extensive dedication to local sports provided by the newspapers of the time. (Appeared in the September 6, 1931 edition of *The Milwaukee Sentinel*, from the collection of Rex Hamann.)

BENNY BENGOUGH (1931–1933). Debuting with the Brewers in 1931, Bengough caught in 20 games for the Brew Boys after finishing his long tenure with the New York Yankees. Returning to Milwaukee in 1933, he donned the mask in 54 games while hitting .236. (From the collection of Bob Koehler)

SCOREBOARD AND ADVERTISEMENTS AT BORCHERT FIELD. In this photo (*circa* 1930) of the tall wall in the outfield at Borchert Field, various local advertising is shown. With a little research, the exact date of the photo could be determined using the scores as presented on the scoreboard. Koolmotor later became Citgo and Wadham's became Mobil Oil. WTMJ, 620-AM in Milwaukee, remains a Clearchannel radio station sending its signal throughout Wisconsin. (Courtesy of the Milwaukee Public Library.)

JACK "NAP" KLOZA (1931; 1933–1936). The outfielder shared his 1931 season with the St. Louis Brown (3 games), but proved much more effective as a Brewer. Appearing in 133 games, he batted .319 in 492 at-bats, and furthered his impact by belting out a team-high 22 homers. A native of Poland, Kloza continued played for Milwaukee for the next two seasons, living out his life in the Cream City. (Photo from the collection of Bob Koehler)

ANTON "TONY" KUBEK (1930–1935). The native Milwaukeean covered the outfield for six years in a Brewer uniform. In his first full season in '31, he batted .357 in 280 official at-bats from the left side, appearing in 101 games and had +.300 seasons for the following two years. He is the father of All-Star Yankee infielder and former radio/television broadcaster Tony Kubek (1957–1965). (Photo from the collection of Bob Koehler)

ALEX METZLER (1931–1933). After a six-season career in the majors, the outfielder came to Milwaukee and quickly posted some amazing numbers. The lefty banged out 213 hits in 623 at-bats for a hopping .342 batting average. Metzler ripped 38 doubles and 14 home runs in the process. (From the collection of Bob Koehler.)

CLYDE "PETE" MANION (1931). During his only season with Milwaukee, the catcher appeared in 138 games and hit a walloping .353 in 464 at-bats! The Missourian was a major league catcher for 13 seasons from 1920 to 1934. (From the collection of Bob Koehler.)

FRANK O'ROURKE (1931–1933). Taking over for Marty Berghammer as manager, O'Rourke had plenty of diamond dust in his shoes after 14 major league seasons (1912–1931). Known as "Blackie," the 36-year-old Canadian also manned the hot-corner for Milwaukee in 47 games during his first year, wielding a hot bat as his .304 average attests. (From the collection of Bob Koehler.)

JACKIE TAVENER (1931–1932). Known as "Rabbit," the former successful major league shortstop came to the Brewers at the age of 33 and quickly proved his resiliency by leading the American Association in at-bats with 702 while hitting .265. His 73 walks made him a good man to have at the top of the batting order. The 5'5" Tavener hit 30 doubles in his debut year for Milwaukee but struck out a league-leading 74 times in 1931. (From the collection of Bob Koehler.)

ART SHIRES (1931). Shires' bat could do no wrong during the '31 campaign as he mustered a mountainous .385 batting average (a league high) in 623 at-bats while covering the first sack for the Brew Crew. While speed was not his greatest asset (8 stolen bases), he managed to strikeout only 30 times while accepting 71 bases on balls. Shires struck out only once for every 20.8 at-bats. His 45 doubles topped the team while his 240 hits was also a league best. He earned the monikers "Art the Great" and "What-A-Man." Shires was one of the original Milwaukee "Bad Boys." A boxer in the off-season, Shires was one tough dude, and prone to proving it on and off the ball field. (From the collection of Bob Koehler.)

MERTON "SPECS" NELSON (1931–1932). Warming up along the sidelines, Nelson's well-polished shoes may give an indication of the attitude these players brought to the ballpark. Nelson appeared in 40 games in 1931, earning six wins against eight losses with a 4.96 ERA through 127 innings. (From the collection of Bob Koehler.)

TEDD GULLIC AND TOT PRESSNELL. Gullic came to Milwaukee from the Wichita Falls Spudders of the B Class Texas league midway through the 1931 season when he quickly impressed Milwaukee fans with his hitting. Pressnell arrived in Milwaukee in 1933, bringing his sidearm style of pitching to the Brewer pitching staff. While the date of this photo does not coincide with the exact time period for the tenure of either player, it is interesting to note that the two had a friendship prior to becoming icons in the history of the Milwaukee Brewers baseball club. The notation appearing on the photo was likely made by Gullic's wife, Thelma. (Photo a gift of Jeanne Gullic Squires in the collection of Rex Hamann.)

NORTHERNER AND SOUTHERNER. Bunny Brief and Ivy Griffin were an inestimable pair and their solid swinging came to epitomize Milwaukee baseball during the mid-to-late 1920s. Hailing from near Big Rapids, Michigan, the 6'0, 185 lb. Brief occupied the outfield and first base while Griffin, a native of Thomasville, Alabama, at 5'11, 180 lbs., was the regular first sacker through 1928. (Courtesy of Lance Richbourg, Jr.)

Four
The Rise and Fall Decade
1932–1941

Fan attendance at the beginning of the fourth decade of Brewer baseball in Milwaukee was at its lowest since the mid- to late teens, as the nation's economic depression was affecting the spending habits of millions of people. Somewhat surprisingly, however, gate receipts at American Association parks in Columbus and Minneapolis showed a surge. Despite the low fan turnout at Borchert Field, however, the Brewers fielded a respectable team under manager Frank "Blackie" O'Rourke who piloted his squad to a record of 88-78, finishing the season 11 games out of first-place in 1932.

In 1933, when Prohibition ended, the Suds Boys slipped to a seventh-place finish under O'Rourke, 20 games under .500. A spark was missing from the lineup as the team finished with a batting average of .283, well below the league average. Third baseman Horace Pip Koehler was the team's leading clubber with his .318 batting average in a yeoman-like 644 at-bats. Bud "Mike" Connolly hit 18 homers, but the runners-up in that department, George "Buck" Stanton and Jack "Nap" Kloza, had half that number.

After a resurgence into the first division in '34 under the venerable baseball man Allan Sothoron, the Brewers were back in form with their 82-70 record, finishing the season only $4^1/_2$ games behind the top seeded Minneapolis Millers. Brewer catcher Earl Webb, at the age of 36, appeared behind the plate in 104 games, had 424 at-bats, and hit a gargantuan .368 to lead the league. Despite Webb's .338 batting average the following year, the Brewers dipped again in the standings, winding up in sixth place.

But the 1936 season become one for the record books. Rising like the frothy head of a freshly-poured Milwaukee beer, the Brew Boys looked like winners during the entire campaign. Described as one of the most potent and balanced teams in minor league history, the Brewers team batting average wasn't quite impressive at .295, the league average. But their three top pitchers each won 19 games; the combined record of Forest "Tot" Pressnell, Joe Heving and Luke "Hot Potato" Hamlin was 57 wins against 35 losses, while each sported an ERA well under 4.00. Tedd "Ol' Reliable" (*aka* "Mr. Brewer") Gullic was on his way to a career season before an injury caught up with him and chilled his sizzling bat; the stalwart outfielder ended up hitting .329. But Rudy York, the longtime catcher/first-baseman for the Detroit Tigers, joined the Brew Crew for the 1936 campaign, and his expertise with the bat was amply demonstrated by his .334 average in 619 at-bats. Milwaukee native Chet Laabs, who would figure prominently in the future success of the Tigers and St. Louis Browns, did his hometown fans proud with his all-around talent, finishing the season with 42 home runs to lead the league, a team-leading 151 RBIs, and a .324 batting clip. Al Sothoron's crew won 90 games against 64 losses, taking over first place and ultimately moving on to capture the Governor's Cup in the league's new playoff system as the Brewers defeated Kansas City and Indianapolis in post-season play.

The following seasons, after losing the big bats of York and Laabs, the Brewers returned to earth and finished in 4th-place in 1937, 3rd-place in 1938 (under Sothoron), and 6th-place under new skipper Minor "Mickey" Heath (who would later broadcast games for the Brewers on radio) before being relegated to the basement of the American Association during the final two years of the decade (1940 and '41).

GARLAND BRAXTON (1932–1936). Taking the mound for Milwaukee from 1932 to 1936, Braxton was one of the Brewers' most effective pitchers. After going 8-11 in his debut year, he found his form for the next few seasons, compiling records of 16-7, 20-7, 17-10 and 9-12 from 1933 to 1936. The southpaw from North Carolina posted a 50-53 record in ten major league seasons (1921–1933). (From the collection of Bob Koehler.)

CLARENCE "DUTCH" (*aka* "RED") HOFFMAN (1932–1933). In his first of two seasons with the Brewers, the outfielder appeared in 79 games and made the most of it as shown by his king-sized .352 batting average. He was traded to Indianapolis early in 1933. (From the collection of Bob Koehler.)

LIN STORTI (1934–1938). With four seasons at the major league level under his belt (St. Louis Browns, 1930–1933), Storti really feathered his nest at Milwaukee's Borchert Field. In his first season as a Brewer, Storti let his bat do the squawking as he belted out a team-leading 35 homers while batting .330. Milwaukee fans would be happy he occupied the second base position for the next four years, as his power brought him to second place among all-time Brewer home run hitters with 141. (From the collection of Bob Koehler.)

HI BELL (1925; 1936). Herman Bell was a workhorse on the mound during the 1925 season, pitching 323 innings for the Brewers and compiling a record of 18-19. He led the team in strikeouts with 124 and with an ERA of 3.90 while appearing in 50 games that year. Bell returned to Milwaukee in 1936 to post a 1-1 record after a respectable eight seasons in the majors. (From the collection of Bob Koehler.)

THE 1935 MILWAUKEE BREWERS. Coming off a third-place finish (82-70) in 1934, the Brewers slipped to the fifth spot for 1935, again under manager Allan Sothoron who took over the reigns in '34. Garland Braxton led the pitching staff with 17 wins against ten losses in 246 innings, and his ERA of 3.22 ranked second on the team to Clyde Hatter's league-leading 2.88 (7-3, 100 innings). Brewer hitters were led by Earl Webb's .338 in 533 at-bats. Outfielder/first baseman Tedd "Old Reliable" Gullic, in his fourth year with Milwaukee, led the league in doubles with 44 while hitting at a cool clip of .323 in 607 at-bats. Gullic is seated front row, far right; manager Sothoron is in the fourth row, far left. Future major league star Chet Laabs is in the third row, fourth from right. This photo was possibly taken at the Brewers' spring training site at Ocala, Florida. (From the collection of Rex Hamann.)

FROM LINE DRIVES TO FOOD DRIVES. These six Milwaukee players brought home the bacon in adifferent way when they helped lead a food drive for the community in 1934. Pictured, from left to right, are Rudy Laskowski (utility), Lou "Crip" Polli (p), Lin Storti (2b), Tony Kubek (of), Jack "Nap" Kloza (of), and Forest "Tot" Pressnell (p). (Courtesy of Patsy Pressnell Woolley.)

LUKE "HOT POTATO" HAMLIN (1935–1936). In this photo (*circa* 1935), Hamlin takes a whack and watches as the sphere grows smaller, deep into the Milwaukee afternoon at Borchert Field, for perhaps his only double of the season. Hamlin was a right-handed pitcher who batted from the left side. Not known for his hitting (.170 batting average), Hamlin helped lead the charge of the mound corps with 19 wins against 14 losses and an ERA of 3.82. (Gift of Jeanne Gullic Squires in the collection of Rex Hamann.)

THE 1936 AMERICAN ASSOCIATION CHAMPION MILWAUKEE BREWERS. In their first season conquering the American Association since 1914, the 1936 Brewers were considered by some to be the best overall team in American Association history. Some claim this Milwaukee team ranks with the best teams in all of minor league history. Under Allan Sothoron, the Brewers were able to combine for 90 wins against 64 losses, overcoming St. Paul by five games. The Brewers then captured the coveted Governor's Cup by defeating Indianapolis in the newly-established playoff system, and went on to defeat the Buffalo Bisons of the International League in the Junior World Series, four games to one, to round out Sothoron's achievement. (From the collection of Rex Hamann.)

THE BREWER FIGHT SONG. How many minor league baseball teams could sport their very own fight song? (In fact, at least one other American Association team had one, the Columbus Red Birds.) This catchy tune is typically high-spirited and was probably heard in various saloons around town, particularly after one of Milwaukee's wins. It is copyright 1936, which is fitting in light of the championship team the Brewers produced. (Words by Michael Neyses, music by Oscar Baker. Copyright 1936 by Badger Music Publishing Company, Milwaukee, Wisconsin.) What a promo! Not that this particular piece of music is definitively a "Brewers" song, but considering the publisher and the cover art, it's a safe bet that the team provided the inspiration. (From the collection of Rex Hamann.)

"BREWERS GIRLS" WITH TOT PRESSNELL (1933–1937). Now here's a complete cheering section unto themselves. The patron saint of the Brewer pitching staff pictured with the ladies is, fittingly, "Tot" Pressnell in this *circa* 1936 photo. (Courtesy of Patsy Pressnell Woolley.)

KEN KELTNER (1937). Homegrown and destined for stardom in the majors, Keltner spent the 1937 season with the Brewers in a dual role as third baseman and outfielder in a combined 142 games. Keltner led the team in homers with 27, runs with 120, while hitting at a cool .310 clip. His swing was in need of some adjustment, as he led the American Association with 92 strikeouts. The Milwaukee native went on to a 13-year major league career, spending 12 of those with the Cleveland Indians. He appeared as an All-Star during seven of those seasons as a third baseman. Keltner died on December 12, 1991, and is interred at Wisconsin Memorial Gardens in Milwaukee. (From the collection of Rex Hamann.)

ROY JOHNSON (1938–1939). Joining the Brewer outfield at the age of 35 after a successful ten-season stint in the majors, Johnson still had plenty of pop in his stick and juice in his legs. He stole a team-second 14 bases while hitting .301 for the third-place Brewers during his debut season in Milwaukee. He slowed down on the base paths during the '39 season, but still hit well as shown by his .296 batting average. He was part Cherokee and the brother of "Indian Bob" Johnson, another star major leaguer. (Courtesy of the Milwaukee Public Library.)

WHITLOW WYATT (1938). This photo shows Wyatt wearing a Brewer uniform as he warms up along the sidelines before a game at Borchert Field. Whitlow "Whit" Wyatt performed at an optimal level for the Milwaukees in '38, compiling a record of 23 wins and seven losses with 208 strikeouts and a sterling ERA of 2.37. He put together one of the best seasons for a pitcher in American Association history, leading the league in wins, winning percentage (.767), games stared (32), shutouts (9), strikeouts and ERA. Wyatt had a fine record of 106-95 in the majors (1929–1945) with such teams as Detroit and Chicago (AL) and Brooklyn (NL). (Photo a gift of Jeanne Squires in the collection of Rex Hamann.)

BREWER BRASS. In this 1937 photo taken at Borchert Field, Brewer bopper Tedd Gullic (left) jazzes it up with teammates Tot Pressnell on tuba and Lin Storti (right), injecting a bit of

ALAN HALE AND THE 1937 MILWAUKEE BREWERS. This photo was a giveaway at Borchert Field for Radio Appreciation Night when the voice of the Brewers, Alan Hale, was honored. The broadcaster had an interesting past; some years earlier, Hale was an FBI agent who assisted in the arrest of John Dillinger in Chicago. According to Jeanne Gullic Squires, Hale's real name was Alan Schuss, but the "G-Man" took on a pseudonym after the demise of the infamous mafia crime boss. Hale, or Schuss, relocated to Portland, Oregon, not long after this photo was taken. He resumed the use of his original family name, working games for the Portland Beavers of the Pacific Coast League—apparently, Milwaukee wasn't far enough away from Chicago! (From the collection of Rex Hamann.)

musical levity to the daily grind of the thirties ballplayer. It is unlikely that either player is "giving wind" in this frolicsome photograph. (Courtesy of Patsy Woolley.)

87

RALPH WINEGARNER (1938–1939). Versatility characterizes Winegarner's short stint in a Milwaukee uniform. In '38 he pitched in 29 games, garnering a record of 6-10, while taking on duties at third and first base. He hit .318 in 173 at-bats. The following year he hit .300 in 263 at-bats while covering first base and the outfield. (Courtesy of the Milwaukee Public Library.)

KEN JUNGELS (1938–1940). The righty's best season with the Brewers was in 1938 when he went 7-7 with an ERA of 4.71 for the third-place Brewers under Allan Sothoron. In 1939, Jungels went 10-16 in wins and losses, but hit .308 in 78 at-bats in contributing to the Brewers' cause. (Courtesy of the Milwaukee Public Library.)

CHARLES "BUCK" MARROW (1938–1941). Marrow's high-kick style off the mound helped bring 15 wins to the Brewers in 1939 against nine losses. Opposing hitters figured out his deceptive style in 1940 when Marrow led the league in losses with 19 against eight wins. (Courtesy of the Milwaukee Public Library.)

GEORGE BLAEHOLDER (1937–1942). Right-hand pitcher George Franklin Blaeholder compiled a record of 52-54 for the Brewers from 1937 to 1942. 1941, when he won nine and lost seven, was his best season. In 1940 he won ten games for the last-place Brewers while losing ten and putting up a respectable ERA of 3.39. He came to the Brewers at the age of 33 after a lengthy career with the St. Louis Browns (1925; 1927–1935), assembling a major league record of 104-125. (From the collection of Rex Hamann.)

TEX CARLETON (1939). The right-hand throwing switch-hitter had several exemplary seasons pitching for the St. Louis Cardinals and the Chicago Cubs during the 1930's. As a Brewer, James Otto Carleton pitched in 30 games with 202 innings of work in 1939, compiling a record of 11-9 and an ERA of 4.23. The 6' 1.5" Texan came to Milwaukee at the age of 32. (Courtesy of the Milwaukee Public Library.)

THE 1938 MILWAUKEE BREWERS. As the nation's depression slowly faded from memory and a war coming on, the Brewers rebounded from their disappointing fourth-place finish in 1937 to capture the third spot in the AA standings with a record of 81-70 under Allan Sothoron's last year as manager. Sothoron died prematurely on June 17, 1939, in St. Louis at the age of 46. Despite "Old Reliable" Tedd Gullic (center, far right) leading the charge with his .313 batting average, Brewers batting averages were down considerably from the previous year. The American Association cumulative batting average stood at .278, down from .291 the previous year. Minor Wilson "Mickey" Heath, native of Toledo, Ohio, led the team in homers with 32. (From the collection of Rex Hamann.)

Joe Just (1938–1939; 1941; 1949–1950). Milwaukee native Joe Just (born Joseph Edwin Juszczak on January 8, 1916) figured into the workings of the club across three decades. Never a star figure as a Brewer, Just's stick-to-itiveness was a tribute to his dedication to baseball in Milwaukee. Just hit .261 in 1938 in 199 at-bats, his best season as a Brewer. Shown here in a Cincinnati Reds' uniform (*circa* 1944), Just played in 25 games as a major leaguer with Cinci. In his later years with the Brew Crew, Just acted as a coach. He died in Franklin, Wisconsin, in November of 2003. (Photo a gift of Mrs. Joe Just in the collection of Rex Hamann.)

Chico Hernandez (1938–1939). Born Salvador José (Ramos) Hernandez on January 3, 1916, at Havana, Cuba, the Brewers acquired him in 1938. Hernandez didn't impact the club until his second year when he filled the backstop's position in 95 games and hit .297 in 303 at-bats. (Courtesy of the Milwaukee Public Library.)

HAL PECK (1940–1944). In his first year with Milwaukee, the native of Big Bend, Wisconsin, grabbed a spot in the outfield and hit .294 as a 23-year-old for the eighth-place Brewers. Despite blasting off his toe while aiming at rats in the barn near his Genesee, Wisconsin home during the off-season in 1944–1945, Peck played in his first full season in with the Philadelphia Athletics in 1945. He played in a total of 355 major league games. (From the collection of Rex Hamann.)

FRED "FRITZ" SCHULTE (1924–1926; 1938–1939). One of Otto Borchert's key acquisitions during the 1920s, Schulte went on to a favorable career with the St. Louis Browns and Washington Senators (1927–1935) before returning to Milwaukee to round out his baseball career. The native of Belleville, Illinois, hit .298 upon his return to the Brewers in his 69 games roaming the outfield at Borchert Field. (Courtesy of the Milwaukee Public Library.)

Five
Wither the Foam Atop the Brew
1942–1952

During the final era of American Association baseball in Milwaukee, the Brewers had their most successful decade with five first-place finishes: 1943-1945, 1951 and 1952. In addition, their winning ways extended into numerous play-off opportunities (see Appendix A, p. 127) as well as two Junior World Series Championships.

The face of minor league baseball had changed considerably since the first three decades of the century, when teams in the American Association were owned independently, by and large. But the advent of the farm system changed all that; players were shifted with increasing regularity from the minors to the parent club (and vice versa), diminishing their competitive edge in comparison with the earlier teams. Gone were the days of minor league club owners selling off their marquee players for handsome profits (as in the case of Larry Chappelle in 1913). During the 1940s through the early '50s, the Brewers had working relationships with the Chicago Cubs and Boston Braves.

The Brewer managers during this decade were Charlie Grimm (1942–1943*; 1951; 1952*), Casey Stengel (1944), Nick Cullop (1945–1949), Bob Coleman (1950), Bucky Walters (1952*) and Red Smith (1952*). (The * denotes a partial season)

The ball club was floundering during the early years of World War II, but a dynamic young entrepreneur named Bill Veeck came on board as the Brewers' president in 1941, bringing former Chicago Cubs' star Charlie Grimm along to manage the club. Veeck quickly employed numerous colorful (and controversial) tactics for regenerating the public's interest in the club. One of which was to offer morning games in order to accommodate third-shift workers at the city's factories. The gregarious Veeck often mingled with the crowd as a way of promoting his team. After the 1943 season, Veeck enlisted with the Marine Corps. In 1944 Charlie Grimm accepted a position managing the Chicago Cubs after bringing the Brewers to a 10-2 record, the Brewers brought veteran baseball man Casey Stengel aboard to skipper the team in Grimm's wake—much to the dismay of Veeck who was overseas fighting for his country. Stengel proved the correct choice, as he helped bring the team to its second straight first-place finish in 1944.

Nick "Old Tomato Face" Cullop's tenure as the Brewer's Field General was notable, not just for the five years he served in that role but also for the high level of competitiveness he garnered from his teams. The bellicose manager was well liked by players and fans alike.

The advent of the television would eventually play a significant role in the in decline in popularity of minor league baseball, but its novelty hadn't worn off just yet. The first televised game from Borchert Field took place on Tuesday, April 27, 1948, during an afternoon contest between the Milwaukee Brewers and the Toledo Mud Hens. WTMJ-TV's Larry Clark covered the action. It was also the first television broadcast of a professional baseball game in the history of the state of Wisconsin.

HY VANDENBERG (1942; 1946). After pitching with various clubs in the International League from 1935 to 1940 and a few cups of coffee in the majors, Harold "Hy" Vandenberg debuted in the American Association in a Milwaukee uniform. He promptly demonstrated veteran form, earning 17 wins against 10 losses in 235 innings for the second-place Brewers under Charlie Grimm. Grimm's lads finished a scant game and a half behind Johnny Neun's Kansas City Blues. In this photo, Vandenberg is shown playing ball with his dog Gypsy. Vandenberg's grave is located at Lakewood Cemetery in Minneapolis, Minnesota. (Photo a gift of Jeanne Gullic Squires in the collection of Rex Hamann.)

BILL FLEMING (1943). In Fleming's only year with the Brewers, he helped lead the team to first place with his record of eight wins and six losses. A righty, Leslie Fletchard Fleming played for the Boston Red Sox and Chicago Cubs during the 1940s. (From the collection of Bob Koehler.)

HEINZ BECKER (1942–1944; 1947–1948), HANK HELF (1937; 1943), GREY CLARKE (1942–1943) AND HAL PECK. This popular international trio starred for the Brewers during the 1940s. Becker was a native of Germany, while Helf hailed from Texas and "Noisy" Clarke had his roots in Alabama. Peck was from the Badger State. (From the collection of Bob Koehler.)

A Comical Look at Borchert Orchard. Graphic artist Fred Steffan outdid himself with this *circa* 1945 rendition of the Brewers' home ballpark. (From the collection of Rex Hamann.)

HANK HELF (1937; 1943). After his initial stint with the Brewers in 1937, Helf had a cup of coffee with the Cleveland Indians. While in Cleveland, he participated in a stunt on August 20, 1938, when he caught a baseball dropped from the top of Cleveland's Terminal Tower by fellow Indians' catcher Frank Pytlak, setting the all-time altitude mark for catching a baseball. Helf returned to Milwaukee for the '43 season, after serving in the U.S. Navy, and hit .260. (From the collection of Bob Koehler.)

HERSCHEL MARTIN (1942–1944). Martin roamed the outfield and took over first base duty for the Brewers, putting up some impressive numbers at the plate—a .307 batting average in 1943, his first full season (492 at-bats), followed by a .358 average in 218 at-bats in 1944. (From the collection of Bob Koehler.)

JULIO ACOSTA (1943–1945). The popular Brewer pitcher stands relaxed before an afternoon game at Borchert Field in this photo. Acosta went 3-1 during his first year with the Brewers, followed by 13-10 in 1944 and 15-10 in 1945. (From the collection of Rex Hamann.)

GEORGE BINKS (1941; 1944). Binks started out his Milwaukee career in five games at first base when he hit a promising .444 in 18 at-bats in 1941. He followed up by playing in 100 games (58 in the outfield and 13 at first base) in 1944 when he hit a colossal .374 in 281 at-bats. Binks was born George Alvin Binkowski in Chicago on July 11, 1916. He performed in the American League for five seasons (1944-1948). (From the collection of Rex Hamann.)

JIMMY PRUETT (1943–1944). Posing for the camera, this snapshot shows the Brewers catcher in his follow-through. Pruett netted a .287 batting average in 122 at-bats during his first season in Milwaukee, then boosted his offensive output for the first-place Brew Crew in '44, pounding out 111 hits in 356 at-bats for a crisp .312 average. Born in Nashville, Tennessee, Pruett died on July 29, 2003, at the age of 85 in Waukesha, Wisconsin. (From the collection of Rex Hamann.)

TOMMY NELSON (1943–1944). Probably on his way down to Sluggy Walter's Borchert Field neighborhood tavern after a big Brewer win, Nelson shows off his stylish fashion of the '40s. Nelson was a versatile infielder who hit .256 in 1943. The following season as the Suds Boys' second baseman he put up a .303 average in 518 at-bats. (From the collection of Bob Koehler.)

FRANK KERR (1948). In his only year as a Brewer, Kerr had backstop duties in 46 games while appearing in 68 contests, compiling a batting average of .271 in 166 at-bats. (From the collection of Bob Koehler.)

GRIMM GREETINGS FOR OPPONENTS. In this photo (*circa* 1943), Brewers pitcher Julio Acosta is shown with manager Charlie Grimm on the occasion of Acosta's birthday. The monstrous cake

CHARLIE GRIMM (1941–1944; 1951–1952). The former Chicago Cubs star first baseman helped usher in a winning era at Borchert Field as the manager of the Milwaukee Brewers. "Jolly Cholly" first took the helm in Milwaukee in 1941, replacing "Reindeer Bill" Killefer midway through the season. (From the collection of Rex Hamann.)

was wheeled in, and Acosta sprang from the cake. These guys knew how to have fun. (From the collection of Bob Koehler.)

CHARLIE "JOLLY CHOLLY" GRIMM. Grimm was known for his banjo-strumming exploits in his efforts to raise either his own mood or that of his team. (From the collection of Rex Hamann.)

NICK CULLOP (1945–1949). Born Heinrich Nicholas Kohlhepp on October 16, 1900, Henry "Nick" Cullop owned various nicknames, including "Ole Tomato Face," "Hipper Dipper," and "Old Nicodemus." Cullop has been described as one of minor league baseball's most colorful stars. For several decades he held the all-time minor league record for career RBIs with a grand total of 1,857. His career in the minors spanned three decades, beginning in 1920, and included being the manager of the Milwaukee Brewers in 1949. His playing career ended in 1944 when he pinch-hit for Columbus where he managed the American Association Red Birds. Nick received numerous awards during his career. As the Milwaukee skipper, he led the team to first place during his first season with the Brewers in 1945, but Louisville defeated them in the first round of the playoffs. All tolled, Cullop's record managing Milwaukee stands at 407 wins and 355 losses, a .534 winning percentage. (From the collection of Rex Hamann.)

EARL "TEACH" CALDWELL (1931–1933; 1943–1944). An example of a pitcher whose early career in the American Association led to his eventual break into the majors, Caldwell first played for the Brewers in 1931, at the age of 26, when he recorded a 15-15 record. In his second year with Milwaukee he racked up 14 wins against 17 losses. In '33 he led the league in losses with 18 with ten wins. After a spell in the majors he returned to Milwaukee in 1943, with a record of 10-11. But it was in 1944 when he reached his peak, winning a league high 19 wins against only five losses in 29 games, assisting the Brewers in their drive for first place in the American Association. (From the collection of Rex Hamann.)

WES LIVENGOOD (1943; 1946–1947). The 6'2" North Carolinian's best season with Milwaukee occurred in his first season, as a 32-year-old right-hander, when he racked up 18 wins against ten losses (a duplicate of mound-mate Joe Berry's). His sparkling ERA of 3.04 contributed substantially to the Brewers' drive for the American Association pennant in 1943. Charlie Grimm's Brewers took first place by $5^1/_2$ games over Indianapolis, but promptly lost the first round of the playoffs, three games to one, to Columbus, which went on to become the AA Champions. (From the collection of Rex Hamann.)

PAUL ERICKSON (1943). In his only season as a Brew Boy, Erickson went 6-4 with a nice ERA of 3.19 to his credit. (From the collection of Rex Hamann.)

RED SMITH (1936; 1939). In his substantial career with Milwaukee, the native of Brokaw, Wisconsin, served the team in many capacities, including manager and coach. As an active player at the age of 32, Smith appeared in 12 games, serving in the role of catcher. (From the collection of Rex Hamann.)

TONY YORK (1943). The Brewer shortstop led the league in games with 651 and batted .287 as one of the core infielders on this potent squad, also leading the American Association in hits with 187. Team leader in runs with 109 and strikeouts with 78, York figured prominently in the Brewer leadership of most runs scored by a team in the A.A. (785) and the most hits (1,434). (From the collection of Rex Hamann.)

OWEN SCHEETZ (1943–1946). The Brewer righty had a cup of coffee with the Washington Senators in 1943, but he made himself known in Milwaukee with his 11-7 record in 1944 as he assisted Casey Stengel to the team's second straight first-place finish with 102 wins to 51 losses. But again they suffered the misfortunes of being eliminated in the first-round of the playoffs as Louisville defeated Stengel and the Brewers, four games to two. (From the collection of Rex Hamann.)

CHARLIE SPROULL (1943–1944). A right-hander from Taylorsville, Georgia, Sproull's ERA topped the Brewers fine pitching corps in 1944 with a sterling mark of 2.50 in 187 innings pitched. With a record of 16-7, Sproull's prowess on the mound played a large part in Milwaukee's climb to first place under Casey Stengel. He had three shutouts while earning 11 complete games in 26 games started. Sproull pitched for the Philadelphia Phillies in 1945, earning a record of 4-10. (From the collection of Rex Hamann.)

ALTON "ARKY" BIGGS (1944–1946). The Brewers' primary shortstop in 1945, Biggs filled in at second base as well, covering the core of the infield in a combined 130 games during his first full year in Milwaukee. A dependable batsman, Biggs earned a .320 batting average in 513 at-bats, the best of the Brewer infielders, and raised some handsome offensive numbers—93 runs, 164 hits, 26 doubles, and 64 walks. (From the collection of Rex Hamann.)

FRANK SECORY (1942–1944). The Brewer utility outfielder is perhaps best remembered for his long tenure as a National League umpire, but he was well acquainted with the players' perspective as well. Secory had a .259 career batting average in his three seasons with Milwaukee, in a combined 633 at-bats. His best season was in 1944 when he hit .290 in 248 at-bats, putting up 19 doubles and nine home runs while striking out only nine times. (From the collection of Rex Hamann.)

CHARLIE "SHERIFF" GASSAWAY (1943–1944). Gassaway may as well have worn a badge and holster with the command he took over opposing A.A. teams during the 1944 season. Appearing in 42 games, his record stood at 17-8 after the dust had settled, with 27 games started and 16 complete games, setting down 108 batters in 219 innings of work. But the real "badge" he wore was his gold-plated 2.75 ERA. Gassaway was another critical cog in the Brewer machine under the Ol' Professor, Casey Stengel. (From the collection of Rex Hamann.)

BILL NORMAN (1942–1945). A perennial outfielder of the American Association (1932–1937; 1942–1945), Norman is one of 41 players with ten or more seasons in the league. With a lifetime league batting average of .297, the firebrand Norman was a stormin' hitter who led the league in home runs in 1942 at the age of 32 while carrying a .301 batting average. He had 213 career doubles, complemented by 176 home runs in the A.A. As a Brewer, his batting averages were .301, .275, and .296 before dropping off the table during his final year in the A.A. at .236 in 148 at-bats. Henry Willis Patrick Norman was born on July 16, 1919, in St. Louis, Missouri, and passed away on April 21, 1962, in Milwaukee, Wisconsin. (From the collection of Rex Hamann.)

OTTO DENNING (1945–1947). Denning's only impact season with the Brewers was in 1945 when the first baseman hit .306 and swiped 15 bases, the latter mark a team high. (From the collection of Rex Hamann.)

BILL NAGEL (1944; 1946). The hot-corner specialist for the Brewers in 1944 (109 games, .308 batting average), Nagel moved around in 1946, playing shortstop, third base and the outfield in 15 games. (From the collection of Bob Koehler.)

LEW "NOISY" FLICK (1945–1946). Flick came to Milwaukee after two cup of coffee seasons with the Philadelphia Athletics, and anyone familiar with his batting record would never have guessed how his bat would explode in Borchert Field. As the Brewers regular outfielder during the 1945 season, the 5' 9" lefty fired off a league-high 215 hits to become the American Association's batting champion at a monolithic .374 clip in 575 at-bats! His 32 doubles and ten triples led the team, and with 90 RBIs he captured the Brewers second spot. First-year manager Nick Cullop must have loved the "noise" that came out of Noisy Flick's bat. (From the collection of Rex Hamann.)

DICK CULLER (1944). The shortstop posted a .308 batting average in 629 at-bats during his only season with the Brew Boys. His 30 doubles led the team, as did his 19 stolen bases. The speedy stealer from High Point, North Carolina, had a few years of major league experience behind him when he arrived at Borchert Field at the age of 29. (From the collection of Rex Hamann.)

ED LEVY (1944). The lanky Levy covered third base and the outfield in a utility role for the Brewers in 1944, batting .286 in 126 at-bats. The 6' 5.5" righty played 54 games in the majors during the early 1940s. (From the collection of Rex Hamann.)

CARL LINDQUIST (1945–1946). The 6'2" righty from Morris Run, Pennsylvania, started 19 games, completing 11 games and throwing one shutout, on his way to a tidy 8-5 record for the first-place Brewers during manager Nick Cullop's first season at the helm. In this snapshot he appears to be preparing for a game before a large crowd at Borchert Field. (From the collection of Bob Koehler.)

CASEY STENGEL AND THE FIRST-PLACE MILWAUKEE BREWERS OF 1944. Casey Stengel, the "Ol' Professor," climbed aboard the Brewer bandwagon after skipper Charlie Grimm got called to manage the Chicago Cubs in April of 1944. Stengel inspired his Brew Boys to take first place in the American Association by seven games over Toledo. The second straight year for the Brewers in the top spot, they eclipsed the 100-win mark by posting a decisive record of 102-51. The Louisville Colonels defeated the Brewers in the first round of the playoffs, four games to two, despite the potent bat of first baseman Heinz Becker (.346 bating average), and the Wisconsin-born outfielder Hal Peck (.345 at the plate) who dominated the league with his 200 hits and 140 runs. Outfielder/first-baseman George "Bingo" Binks hit .374 in 281 at-bats. Pitcher Earl Caldwell won a league-topping 19 games against a mere five losses (a .792 league-high winning

THE RUPTURED DUCK INSIGNIA. Each player returning to the Brewers from a stint in the armed services in 1945 received the Ruptured Duck patch on his jersey's left sleeve (a detail of the patch is shown below). The patch is visible in the 1945 team photo on page 114 The image seen here was the subject for the patch given to returning servicemen. (From a 1945 Milwaukee game program in the collection of Rex Hamann.)

percentage) for the Brewers. Charlie Gassaway went 17-8 with a 2.95 ERA. Charlie Sproull had a record of 16-7 in 187 innings of work. From left to right: (front row) Bill Nagel (3b), Heinz Becker (1b), Hal Peck (of), Tommy Nelson (2b), Don Hendrickson (p), Jimmy Pruett (c), Dick Culler (ss), and Charlie Gassaway (p); (middle row) Bob Feron (trainer), Red Smith (coach), Casey Stengel (mgr.), Ken Raddant (c), Ed Schweiwe (ss), Jack Farmer (p), and Rudy Schaffer (general mgr.); (back row) Owen Scheetz (p), Frank Secory (of), Julio Acosta (p), Roy Easterwood (c), Ed Levy (of/3b), Bill Norman (of), Charlie Sproull (p), Earl Caldwell (p), George Binks (of/1b), and Floyd Speer (p). Not pictured: Lou Grasmick (p), Richard Dale Long (of/1b), Arky Biggs, Tom Jordan (c), Bob Bowman (p), Herschel Martin (of), and Dickie Hearn (p). (From the collection of Bob Koehler.)

THE LEAGUE-LEADING MILWAUKEE BREWERS OF 1945. New Brewers manager Henry Nick "Old Tomato Face" Cullop took up where Casey Stengel left off, leading the charge to another first-place A.A. title with a record of 93-61. Hitting from the left side of the plate, outfielder Lew Flick captured the A.A. batting crown with his otherworldly .374 batting average. Flick's 215 hits in 575 at-bats included team highs of 32 doubles and ten triples. His 11 home runs was good for second on the team (to third baseman Gene Nance's 17), and he drove in 92 RBI while scoring a team-second 90 runs. Flick has no apparent relationship with the Hall of Fame outfielder Elmer Flick, but his 1945 numbers indicate Hall of Fame potential! First-baseman Otto Denning ran well with his team-capping 15 stolen bases. Owen Franklin Scheetz took care of things from the mound as he racked up a league-high 19 wins and tallied a lean ERA of 1.95,

JOE STEPHENSON (1945) AND HIS SON JERRY. The Brewers' regular catcher during the 1945 season, Stephenson hit .274 in 405 at-bats while performing receiver duties in 120 games. It was his only year with Milwaukee. He scraped out 15 doubles along with six triples and five home runs. The face of teammate Otto Denning appears at right. Stephenson's son Jerry is now a major league scout with the Boston Red Sox organization. (Photo a gift of Mrs. Joe Stephenson in the collection of Rex Hamann.)

one of the best marks in Brewer history for a starter.

 From left to right: (front row) Rudy Schaffer (general mgr.), John "Jackie" Price (ss/3b), Julio Acosta (p), Joe Stephenson (c), Nick Cullop (mgr.), Bill Veeck (president), Jack McGillen, Floyd Speer, Gene Nance, and Mickey Heath (vice-president); (middle row) Bob Feron (trainer), Joe Rullo (2b), Tom Padden (c), Tony Mazurek (of/1b), Bill Burgo (of), Otto Denning (1b), Lew Flick (of), Arky Biggs (ss/2b), and Chuck Carroll (of); (back row) Elmer Burkart (p), Gene Edwards (c), Ewald Pyle (p), Wendell "Peaches" Davis (p), Carl Lindquist (p), Larry Rosenthal (of), Ray "Bill" Davis (p), Owen Scheetz (p), Armond "Ben" Cardoni (p), and Mike Ulisney (c). (Photo a gift from Harold Esch in the collection of Rex Hamann.)

JOE STEPHENSON WITH OTTO DENNING AND BOB MISTELLE. In this 1945 photo, Brewer catcher Stephenson (center) is shown in the Brewers' clubhouse at Borchert Field with first baseman Otto Denning (left) and pitcher Bob Mistelle (right) who pitched for the Minneapolis Millers later that season. (Photo a gift of Mrs. Joe Stephenson in the collection of Rex Hamann.)

JACKIE PRICE (1945) AND HIS PET SNAKE. As the story goes, John "Jackie" Price, infielder for the Brewers, brought his pet snake into a local movie theatre. The prank took the spotlight as Price's pet took top billing at the show. Price was well known as the "game-player" on the team. He came to Milwaukee from the Columbus Red Birds during the 1945 season. (From the collection of Bob Koehler.)

CARDEN GILLENWATER (1947–1948). A native of Tennessee, the Brewers' starting outfielder came to Milwaukee after a few years at the major league level. He was one of the Brewers top hitters in 1947 with a .312 batting average and team-highs of 23 homers and 92 RBIs. (From the collection of Bob Koehler.)

DANNY "THE WHISTLER" MURTAUGH (1947). The 29-year-old keystone sacker batted .302 in 444 at-bats while stroking 15 doubles and driving in 49 runs in his only season as a Brewer. Murtaugh had previously performed for the Philadelphia Phillies and would later become the property of the Pittsburgh Pirates. He later became the long-term manager for the Pirates. (From the collection of Bob Koehler)

THE 1948 MILWAUKEE BREWERS. Capturing second place with a record of 89-65, Nick Cullop's Brewers finish 11 games in back of the Indianapolis Indians. Fan favorite Heinz Becker led the team with his .321 batting average while covering the first sack. Outfielder Froilan Fernandez took the league lead in games played with 152 and hits with 183 while posting a batting average of .318. Pitchers Glenn Elliott and Al Epperly led the Brewers with 14 wins apiece, with Elliott striking out 125 batters, posting a league-high 3.76 ERA. (From the collection of Bob Koehler.)

DAMON "DEE" PHILLIPS (1948–1949). Phillips hit 16 long balls as the regular Brewer shortstop in '48 while hitting .261 with 78 RBIs. The following year he was converted to a third baseman, upping his average to .286 with 14 homers and 83 RBIs. Phillips broke into the American Association as a shortstop with St. Paul in 1940. (From the collection of Bob Koehler.)

GEORGE ESTOCK AND THE MILWAUKEE BREWERS OF 1950. The Brewers could muster only a sixth-place finish in the A.A. standings under their new manager, 59-year-old Bob Coleman who played major league ball between the years 1913 and 1916. Sixteen of the Brew Crew's 68 wins were won by right-hander George Estock, the league's second leading pitcher in victories. Going 16-8 with a 3.35 ERA, Estock had 16 complete games and one shutout in his 24 games started. Chet Nichols had three shutouts in his 29 games, 19 of which he started, while compiling a 7-14 record. Among hitters, Len Pearson, the Brewers' first black player, covered the first sack while hitting .305 in 223 at-bats. (Graphic a gift of George Estock from the collection of Rex Hamann.)

Climbs and Wins ... By Charles Burns

George **ESTOCK**

25-YEAR-OLD-RIGHTHANDER, WAS ANOTHER PITCHING WINNER THIS SEASON WITH A 16-8 MARK FOR MILWAUKEE... WAS PURCHASED LAST SPRING FROM AUSTIN OF THE BIG STATE LEAGUE AFTER WINNING 39 GAMES THERE IN TWO SEASONS. HIS 22 VICTORIES FOR THE BLUE ROCKS IN 1945 STILL STAND AS THE INTER-STATE LEAGUE RECORD!

ESTOCK, IS A NATIVE OF BRIDGEPORT, CONN., BUT HAS LIVED HERE SINCE HIS MARRIAGE TO THE FORMER JANET FERNALD OF WILMINTON...

FANS' VIEW AT BORCHERT FIELD. The wind blows from the south, aiding the hitters, in this *circa* 1951 photo taken from the first base side of the grandstand at Borchert Field. Note the prevalence of straw hats. (From the collection of Bob Koehler.)

OUTSIDE BORCHERT FIELD. Cars head north along N. 7th Street in Milwaukee searching for a parking place or dropping off patrons of the game on April 16, 1952, the final home opener at the ancient but venerable Borchert Field. (From the collection of Bob Koehler.)

THE BREWMASTERS. This cadre of Brewmaster moundsmen helped a trio of Brewer managers keep the keg full as they poured it on against their A.A. opponents for 1952, earning the top spot in the standings with a record of 101-53. But a few bad "hops" spoiled the batch as Kaysee beat the Brewers, four games to three, in the second round of the playoffs in the final series ever played at Borchert Field. The Blues' Bill "Moose" Skowron hit the final home run at Borchert Field in that series. Pictured, from left to right, are Gene Conley, Virgil Jester, Murray Wall, Dick Donovan, George Estock, Dick Hoover, Bert Thiel, Eddie Blake, and Don Liddle (the league's leading pitcher at 17-4, ERA of 2.70). (Photo a gift from George Estock in the collection of Rex Hamann.)

THE LAST OPENING DAY AT BORCHERT FIELD. Milwaukee baseball fans didn't realize it at the time, but this home opener against the Minneapolis Millers would be their last at the rickety wooden structure at 8th and Chambers Streets—Borchert Field. Construction on the new Milwaukee County Stadium, located some six miles to the southwest, had begun. No one knew the surprise to come. In March of 1953 the Boston Braves organization would chose to make Milwaukee their new home. The Braves played their first game at the new park on April 14, 1953. This decision forced the Brewers to move to Toledo for the 1953 season, beginning a new era as the Toledo Sox. (From the collection of Rex Hamann.)

AERIAL VIEW OF BORCHERT FIELD. This aerial photo was taken sometime during the late 1940s. Visible are the finely groomed grounds that served the sporting community in Milwaukee for two thirds of a century. The pitcher's mound to home plate runs north to south. The site is now occupied by U.S. Interstate Highway 43. Buildings surrounding it, which are visible in this photo, still exist. Neighborhood signs presently posted upon street lampposts in the area commemorate the site, linking it to the "Borchert Field Neighborhood." (From the collection of Rex Hamann.)

BORCHERT FIELD GROUNDS CREW IN ACTION. An old pickup truck on the infield dirt at Borchert Field has brought in the equipment for tending the grounds in preparation for the 1952 home

opener. Considering the mid-April date, the groundskeepers probably feel fortunate that the field is snow free. (From the collection of Bob Koehler.)

JUBILANT OPENING DAY SCENE. A Brewer hit! This glimpse into the faces of the Milwaukee faithful attests to the jubilant mood frequently found at "Borchert Orchard." When the bunting was hung, it must have been a very special place to take in a game. This photo was taken at the final opening day for the Brewers in Borchert Field on April 16, 1952. (From the collection of Bob Koehler.)

"BEST SEAT IN THE HOUSE." The photographer must have been hanging from the rafters to get this interesting view from May 1, 1951. The sight-lines at Borchert Field were the worst in the league. One team owner in the American Association once quipped, "You have to pay two admissions to see a game at Borchert Field. The first day you see what happens in right field. The next day you come back to see what happens in left field." The statement is accurate, according to former patrons interviewed by the author; it was virtually impossible to see the entire field at once for anyone sitting in the grandstands! (From the collection of Bob Koehler.)

Good-bye to Borchert Field. A smartly dressed attendant looks on as remnants of the crowd file out of the ballpark as they leave the scene during what is purportedly the final home game for the American Association's Milwaukee Brewers at Borchert Field. Fifty-one seasons at the little ol' barn at 8th and Chambers, and the course of history is changed forever. Note the unique "angled" shape of the dugout (the same was found on the first-base side). (From the collection of Rex Hamann.)

SOUVENIR DECAL. Perhaps you had one of these "Back Your Brewers" decals on your front door or window as a youngster, telling the world that you were a Brewer Backer. (From the collection of Rex Hamann.)

THE OLD GUARD AT THE OLD GARDEN. Perhaps winter's chill presented optimal conditions for the careful, piece-by-piece disassembly of the wooden stands, which provided a place for Milwaukee baseball fans to cheer on their Brewers for 51 seasons. Thankfully, she was spared the wrecking ball, allowing the recyclers of the area to extend old gal's life. For example, the light poles are still in use for lighting at least one field in a Milwaukee city park. The photographer was looking northeast sometime during the winter of 1953-54. (From collection of Rex Hamann.)

Appendix
The Milwaukee Brewers in Post-Season Play

The American Association had employed a playoff system, known as the Junior (or "Little") World Series, since 1904, but it wasn't until 1917 that a definitive official series was maintained on a regular basis. Until that time, the first-place team was simply known as the American Association Champion, and that team took on the champions of the International League. This changed in 1933 when an "East-West" designation was assigned to the top two teams of the American Association, both of which would enter into a playoff in order to determine who would represent the American Association. In 1936, the Shaughnessy Plan was put into place which allowed the top four teams in the A.A. to battle it out in the following format: 1st place vs. 3rd place teams, and 2nd place vs. 4th place teams. The winner of each of these seven-game series would meet in the Finals; the winner of the Finals earned the American Association Championship, along with the esteemed Governor's Cup and the right to represent the American Association in the Junior World Series.

Here is how Milwaukee has fared in its various post-season play-off romps:

1913: The American Association Champion Milwaukee Brewers defeated the Denver Bears (*aka* Grizzlies, Western League), three games to two, in this unofficial "Miniature World's Series."

1936: Milwaukee finished the regular season in 1st place. The Brewers then defeated the third-place Kansas City Blues in round 1 of the play-offs while the fourth-place Indianapolis Indians defeated the second-place St. Paul Saints. Milwaukee won the Governor's Cup by defeating Indianapolis in the American Association finals. The Brewers then defeated the Buffalo Bisons in five games to earn the Junior World Series crown.

1937: Milwaukee finished in 4th place. Brewers defeated 2nd-place Toledo Mud Hens, 4 games to 2. First-place Columbus Red Birds defeated Brewers, 4 games to 2.

1938: Milwaukee finished in 3rd place. Brewers defeated by first-place St. Paul Saints in first round (4-3).

1942: Finished in 2nd place; defeated by 4th place Toledo Mud Hens (4-2).

1943: Finished in 1st place; defeated by 3rd-place Columbus Red Birds (3-1).

1944: Finished in 1st place; defeated by 3rd-place Louisville Colonels (4-2).

1945: Finished in 1st place; defeated by 3rd-place Louisville Colonels (4-2).

1947: Finished in 3rd place; defeated 1st-place Kansas City Blues (4-2); defeated 2nd-place Louisville Colonels in Finals (4-3). Milwaukee Brewers defeat Syracuse Chiefs of the International League (4-3) to win the Junior World Series crown.

1948: Finished in 2nd place; defeated by Columbus Red Birds (4-3).

1949: Finished in 3rd place; defeated St. Paul Saints (4-3); defeated by Indianapolis Indians in Finals (4-3).

1951: Finished in 1st place; defeated 3rd-place Kansas City Blues (4-1); defeated St. Paul Saints (4-2). Milwaukee Brewers defeat Montreal Royals of the International League (4-2) to capture the Junior World Series crown.

1952: Finished in 1st place; defeat St. Paul Saints (4-0); defeated by Kansas City Blues in Finals (4-3).

Bibliography

All-Time Records and Highlights of the American Association. 1970.
Benson, Michael. *Ballparks of North America*. Jefferson, NC: McFarland & Company, 1989.
Biggers, George. "Winning the Pennant In the American Association." *The Baseball Magazine*, January, 1914.
Buege, Bob. *The Birth of the American League. Baseball in the Badger State*. Cleveland, OH: SABR Publication 31, 2001.
———. E-mail Correspondence. 2003.
Carter, Jimmy. *An Hour Before Daylight*. New York, NY: Touchstone, 2001.
Davids, Robert L. "Nick Cullop, Minor League Great." SABR publication. 19?
Doyle, Pat. *The Professional Baseball Players Database*. Old-Time Data, Inc. 1995–2000.
Filichia, Peter. *Professional Baseball Franchises*. New York, NY: Facts on File, Inc., 1993.
Hamann, Rex D. *The American Association Almanac*, vol. 2, no. 5. Andover, MN: Self-published, 2003.
Holtzman, Jerome and George Vass. *The Chicago Cubs Encyclopedia*. Philadelphia, PA: Temple University Press, 1997.
Honig, Donald. *The American League*. New York, NY: Crown Publishers, Inc., 1993.
Hutchinson, Fred P., ed. *Who's Who in the American Association*, various editions. Minneapolis, MN.
Johnson, Lloyd and Miles Wolff, eds. *The Encyclopedia of Minor League Baseball*. Durham, NC: Baseball America, Inc., 1997.
Koehler, Robert. Roster files for the American Association Milwaukee Brewers. Elm Grove, WI.
Kroll, Wayne L. *Badger Brewers Past & Present*. Jefferson, WI: Self-published, 1976.
Lin Weber, Ralph. *The Toledo Baseball Guide of the Mud Hens 1883–1943*. Rossford, OH: Baseball Research Bureau, 1944.
Milwaukee Brewers Program, 1934.
———, 1945.
O'Neal, Bill. *The American Association, A Baseball History 1902–1991*. Austin, TX: Eakin Press, 1991.
Podoll, Brian A. The Minor League Milwaukee Brewers, 1859–1952. Jefferson, NC: McFarland & Company, 2003.
Rink, Neal. Various correspondences. 2002–2003.
Smalling, Jack. *The Baseball Autograph Collector's Handbook, No. 11*. Durham, NC: Baseball America, Inc., 2001.
Squires, Jeanne. Various correspondences and telephone conversations. 2001–2002.
The Milwaukee Sentinel. 6 September 1931.
The Milwaukee Journal Sentinel. 3 August 2003.
———. 10 December 2003.
The Reach Official Base Ball Guide. 1911.
The Reach Official American League Guide. 1920.
The Record Makers of the American Association, various editions. Minneapolis, MN: The American Association.
The Spalding Official Base Ball Guide. 1909.
The Steubenville (OH) Herald-Star. 30 August 1906.
Thorn, John and Pete Palmer, et al., eds. 6th edition. *Total Baseball*. New York, NY: Total Sports, 1999.
Thornley, Stew. *On to Nicollet*. Minneapolis, MN: Nodin Press, 1988.
Wells, Robert W. *This Is Milwaukee*. Garden City, NY: Doubleday & Company, Inc., 1970.
Wolff, Miles. *The Minor League Register*. Durham, NC: Baseball America, Inc., 1994.
Wright, Marshall D. *The American Association*. Jefferson, NC: McFarland & Company, 1997.

www.paperofrecord.com
www.askjeeves.com
www.baseball-almanac.com
www.baseballLibrary.com